ICONS OF STYLE

Harry Styles

Published in 2023 by Welbeck
An imprint of Welbeck Non-Fiction Limited,
part of Welbeck Publishing Group.
Offices in: London - 20 Mortimer Street, London W1T 3JW &
Sydney - Level 17, 207 Kent St, Sydney NSW 2000 Australia
www.welbeckpublishing.com

A CIP catalogue for this book is available from the British
Library.

ISBN 978-1-80279-618-6

Printed in China

10 9 8 7 6 5 4 3 2 1

ICONS OF STYLE

Harry Styles

The story of a fashion legend

Lauren Cochrane

WELBECK

CHAPTER 3

Designers, Stylists and Design
112

CHAPTER 4

Performance
164

"There's so much joy to be

*had in
playing with
clothes."*

HARRY STYLES

Introduction

Writing in *Better Homes & Gardens* magazine, cultural critic Lou Stoppard describes Harry Styles as "... teddy bears on your teenage bed, perfect handwriting on thank you cards, picked flowers on Sunday morning, puppies running on fresh-cut grass, Grandma's favourite homemade cake." In short, the pop star is pure uncomplicated joy, and in a world that is often all too complicated, that is both a breath of fresh air and a soothing balm.

What Styles wears is as much part of the joy factor as his boyish grin, swoonsome hair or "treat people with kindness" motto. He's even used the word himself to describe how he feels about fashion. "There's so much joy to be had in playing with clothes," he said in 2020. "I've never really thought too much about what it means – it just becomes this extended part of creating something."

When it comes to fashion, the aptly-named Styles has followed his creative instincts towards outfits like a sequined jumpsuit, worn to perform at Coachella in 2022 or a sparkly baseball uniform worn in homage to Elton John for Halloween in 2018. Styles seems to get a thrill out of every look – there's something endearingly childlike in his wonder at the way clothes can make us look and feel.

It's a feeling that's infectious. Just look at the fantastical outfits seen on fans at Styles's gigs and the way that trends or items he's endorsed have found their way into millions of wardrobes. The Styles effect has given new lustre to the

humble pearl. Once the preserve of ladies who lunch, pearls are now worn by twentysomethings of all genders. Or look to statement suits – no longer unusual, they've been taken up by non-celebrity men for special occasions beyond the red carpet without raising too many eyebrows. Then there's nail varnish. Styles's penchant for many-hued fingertips goes back to his days in One Direction and these days the idea that it should be taboo for a man to wear colour on his fingernails (a ridiculously outdated notion, admittedly) has all but vanished – partly thanks to him.

This book accompanies Styles on his sartorial journey. It follows him from his beginnings as something of an indie kid to his boy band years dressed in blazers and hairbands. There's his break-out move to become the twenty-first century answer to rock and roll heroes like Mick Jagger, Prince, David Bowie and Marc Bolan. And you'll see him maturing into his own unique look with the help of stylist Harry Lambert and designers Alessandro Michele, Harris Reed and SS Daley. It's both a nostalgic trip down memory lane (*The X Factor*! That Jack Wills hoodie!) and a way to reflect on how Styles, in the thirteen years since he walked onto that stage to say hi to Simon Cowell, has changed many of our lives, and our style, forever. He continues to bring joy not just to our hearts but to the very act of getting dressed. Long may he reign.

OVERLEAF Glitter, sparkles, pastels and bows … it all added up to a swoonsome outfit in which to play Copenhagen in 2018.

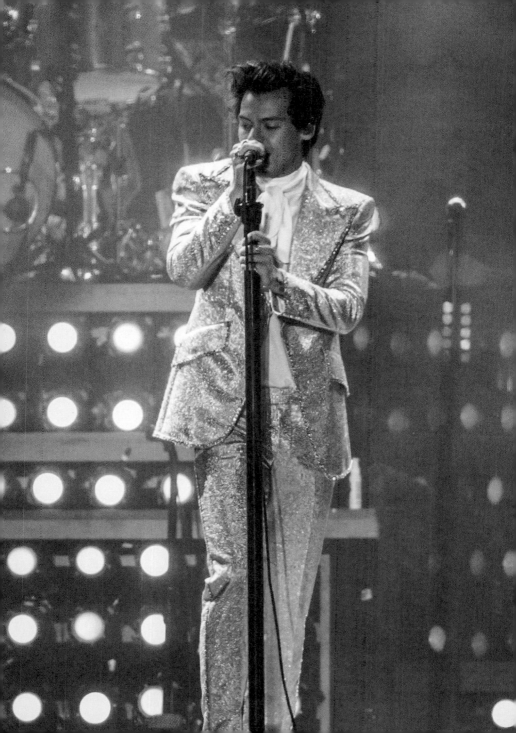

The Early

CHAPTER 1

Years

❡In the beginning...

Harry Styles always liked clothes. "As a kid I definitely liked fancy dress," he told *Vogue* in 2020, revealing that he first wore tights in a school play, in which he'd been cast as Barney, a church mouse. "I remember it was crazy to me that I was wearing a pair of tights," he said. "And that was maybe where it all kicked off!"

There's a picture of Styles as a young child that's often circulated by fans. He might be around six years old – wearing a bra, strapped on over a football shirt. Sure, he's larking around – a little kid who's put on, as a joke, what is probably his mum's bra – but the pose, the grin, the odd combination of football and underwear spells something we now all recognize: Styles's love of clothes and the reactions they can garner.

It wasn't all about clothes as a way to stand out. His sister Gemma has described how her brother took a job at a bakery to fund his fashion addiction. The siblings both loved the skinny jeans, skater trainers and studded belts that dominated the late noughties – the one he's seen wearing in early paparazzi images. This teenage Styles likes fashion, but he doesn't understand it yet. That's why he wears skater jeans with a pink polo shirt, or a creased shirt with a vest. It's why – even after he's joined One Direction – he is happy to

Cardigan, polo shirt, skater jeans, hightops ... and a carrier bag. Styles's teenage style in 2010. Cher Lloyd and Zayn Malik are clearly not impressed.

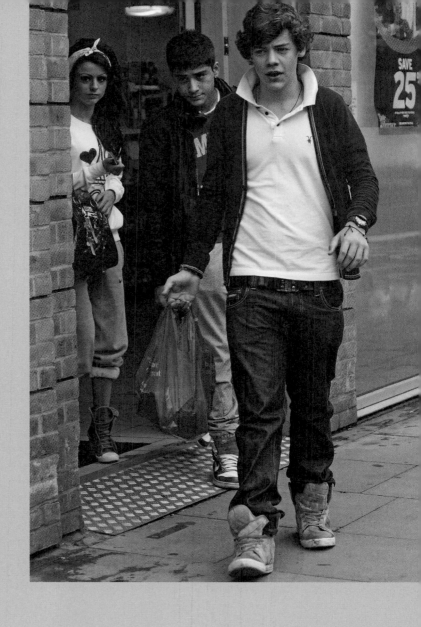

"It began with **White Eskimo** *... See a perfectly dishevelled school uniform and the nascent stylings of* his signature, swoon-worthy feature – *that hair."*

be photographed with that telltale sign of the non-famous: a carrier bag.

Born in 1994 in Redditch – a town whose previous claim to fame was its contribution to the fishing tackle industry – Styles was largely brought up by his mum, Anne Twist, with his older sister Gemma (now an eyewear designer), living in a small village nearby. While his initial ambition was to become a physiotherapist and he took that part-time job as a baker at fourteen, stardom and style icon status soon beckoned.

The "aw" factor was there from the start. You can see it for yourself if you google "Harry Styles as a child". There he is wearing a Goofy sweatshirt; a smart waistcoat; a rather retro green shirt accessorized with a yellow tie. There's even a sweet shot of him at school, featuring short sandy hair and his trademark dimples. All have seen fans lose their minds and Styles lament that he doesn't have any childhood pictures that aren't now online.

His journey as we know it began with White Eskimo – a band with a slightly questionable name that he joined as a teenager, in 2009. Styles was the frontman and if live footage on YouTube is anything to go by, his outfits reflected his star quality – and the era. See a perfectly dishevelled school uniform, a blazer with the sleeves rolled up and the nascent stylings of his signature, swoon-worthy feature – that hair.

Knits, knits and more knits

When Harry Styles auditioned for *The X Factor* in 2010, he was accompanied by a squad of family members who all wore T-shirts proclaiming "we think Harry has the X Factor". It turns out, 13 years later, that they were quite right.

The Styles first seen on *The X Factor* was very different to the one we know today. We can see that in the boyish grin and wide-eyed expression – and in what he wore. 16-year-old Styles's attire embodied the dominant "bedroom indie" aesthetic of the era. He often wore cardigans, nondescript jumpers, skinny jeans and one of those even skinnier scarves that you had to tie around your neck lots of times.

Of course, we all know the rest of the story here. Post-audition, Styles made it through to bootcamp as a solo act but no further. Instead, he was paired with Niall Horan, Liam Payne, Louis Tomlinson, and Zayn Malik to form One Direction. Even when stardom struck, Styles – like his band members – remained a pretty regular teenage boy in lots of ways, especially when it came to his clothes. He tucked his scarf under his shirt, he wore what looked like his mum's jacket to a photocall, he carried a half-eaten banana as an accessory. This was an era of style experimentation, but one still without the polish of full-on pop stardom.

With jeans tucked into boots, and a very sensible jumper, not to mention a banana, *X Factor*-era Styles is cute – if not a style icon quite yet.

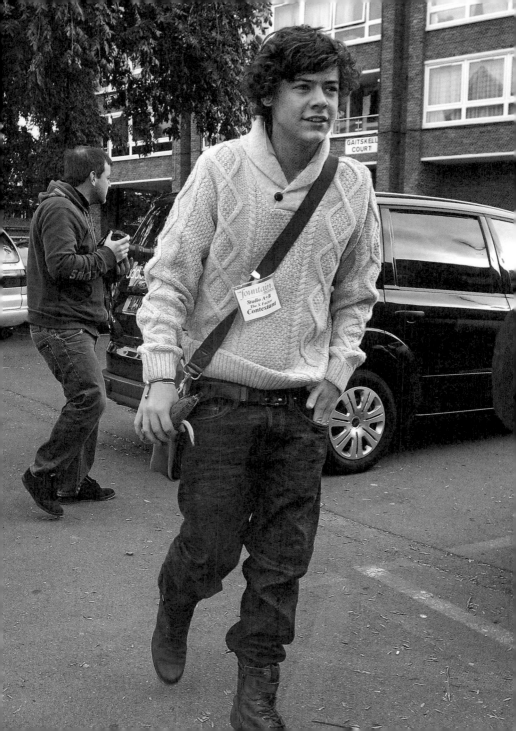

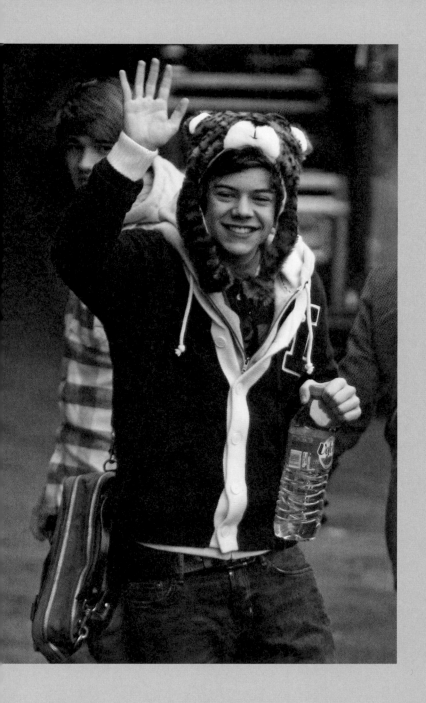

While the group didn't win the series, they did win a lot of hearts, especially Styles. This was in part thanks to his cute-as-a-button looks, but his wardrobe has to be credited too. On the show, the five boys are seen crooning to a perpetually unimpressed Simon Cowell. As, increasingly, they are styled to mirror each other, Styles manages to stand out just a little bit each time – whether it's because he's wearing his trainers too-loose on his feet, or adding a jacket when the rest of the band are in hoodies. For the band's final performance on the show, singing Elton John's "Your Song", he's even been styled in an outfit that echoes the one he wore pre-1D: chunky grey knitwear accessorized with one of those extra-long scarves.

His wardrobe endears him to fans, even if it doesn't make him a style icon quite yet. This is partly because it's exactly what a sixteen-year-old kid in 2010 should be wearing – hoodies, cardigans, trainers and slightly oversized jeans. There are even items that show he's still something of a kid – a knitted hat decorated with a cat's face, its straps resembling paws. We're sorry, Harry: nothing can be forgotten on the internet.

Liam Payne, seen in the background here, might not be on board with Styles's cat hat, but fans thought it was purrfect.

There are, nevertheless, some infamous outfits from this early Styles era that suggest the teenager is moving into anything but average territory. See a street snap of him in a onesie, accessorized with a pair of high-top trainers and an "and what?" expression. It might seem like just youthful experimentation but it shows something shifting – because, well, most 16-year-olds didn't wear onesies in public at this point in time. Just look at Styles's band mates, who conformed to a more typical dress code (jeans, T-shirt and a sweep of hair) that teenagers clung to for fear of standing out. Notably, Styles has remained a loyal fan of the all-in-one – since he's gone solo, the jumpsuit has become a key element of his stage wardrobe.

Speaking to the *Guardian* in 2019, Styles said the most striking thing about his time on *The X Factor* was that "it's so instant. The day before, you've never been on telly. Then suddenly ..." His clothes from the time reflect this. They are a work in progress, a mix and even – ever so sweetly – something of a mess. But, crucially, there's promise there. Promise – and also all-in-ones.

A 16-year-old Styles couldn't have predicted his jumpsuit-clad future – but this onesie, worn with chunky trainers in 2010, feels prescient.

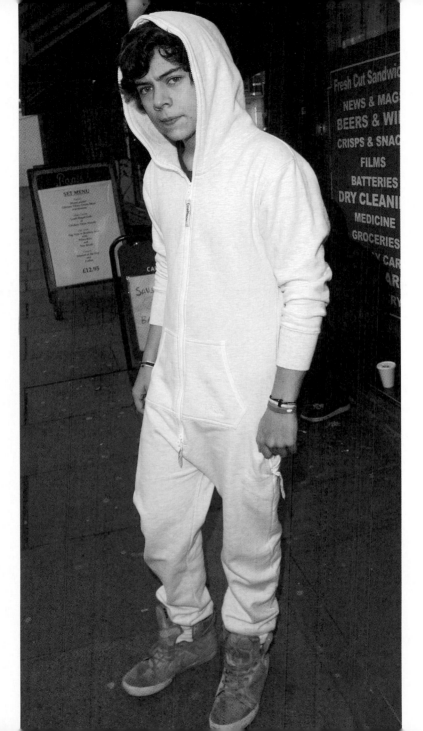

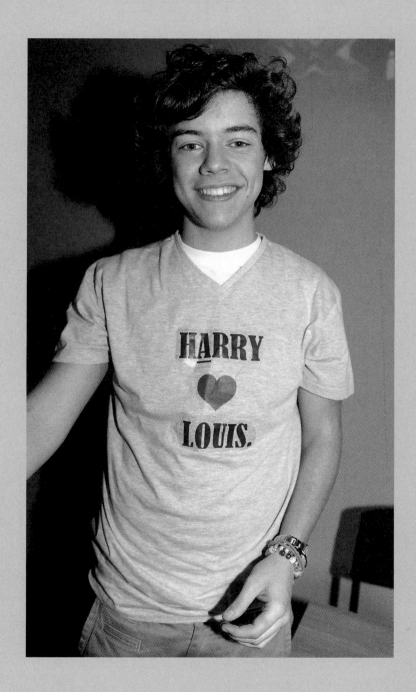

'Live while we're young

It's fair to say that Harry Styles's early career seems to have been on fast forward. At 16, he auditioned for *The X Factor*. By the age of 18, in 2012, he'd moved to London and bought a house (which he still owns). Over those two years, One Direction fever had taken hold not just in the UK but across the world. The group's debut album, *Up All Night*, which contained smash-hit single "What Makes You Beautiful", was released in September 2011. It became the first ever album by a UK group to debut at number one in the United States. That's where the money for the house came from, then.

Styles's style was evolving. It remained cute and boyish, still not quite fully formed, but he was learning how to make use of the limelight to play around with what he wore – and even use clothes to make statements. In 2011, for example, he was photographed in a "Harry hearts Louis" T-shirt given to him by a fan. It was a playful wink to a growing fan fiction narrative sometimes known as Larry Stylinson. The theory had fans exhaustively combing for clues that the closeness between Styles and Tomlinson indicated a romance, not a bromance (sadly for them, it's generally agreed it was more likely the latter).

Styles has always engaged with his fans. This T-shirt is a cheeky nod to a rumour that he and band member Louis Tomlinson were in a relationship.

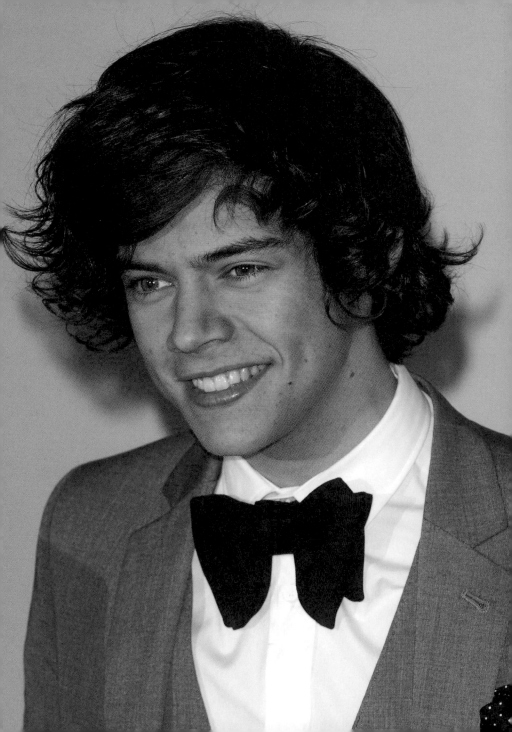

"Styles's style was *evolving* ... *He was learning how to make use of the limelight; to* play *around with what he wore.*"

If you looked up "adorable" in the dictionary, you might see a picture of Harry Styles in a blazer and bow tie circa 2012.

Of course, not all of Styles's fashion statements were attention-grabbing T-shirts. As one of five members of One Direction, he was keen to develop a style signature, and seems to have settled on a blazer. A look that managed to be both grown-up and also endearingly reminiscent of school uniform, it came out for red-carpet events (with a bow tie, no less, for the BRIT Awards in 2012), for gigs (a blue blazer with piping had "umpire at Wimbledon" vibes) and for public appearances. Combined with band T-shirts, that had, for example, a Rolling Stones motif, the blazers not only signalled that Styles knew about music beyond boy band pop. They also aligned him with the growing influence of indie on fashion trends around this time. Is Styles an icon of 2022's "indie sleaze" trend? It could be.

H is for Harry. Styles's blazer era featured many different styles – including this one, channeling "umpire at Wimbledon" vibes.

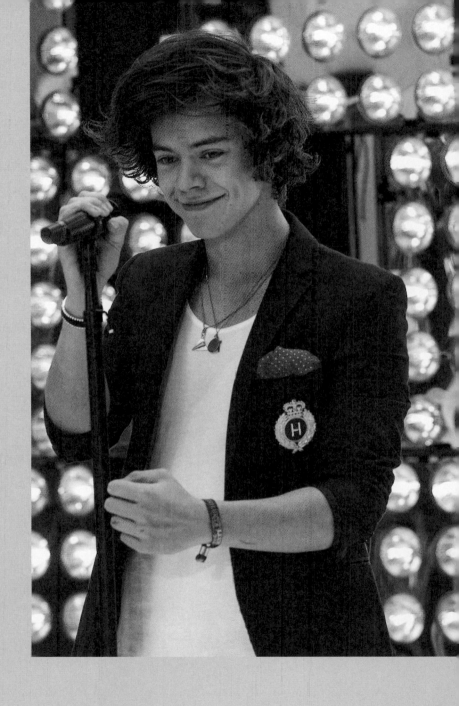

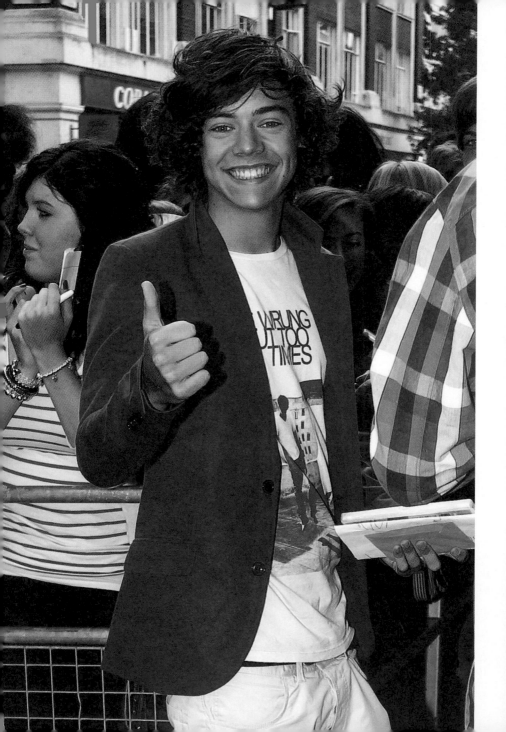

The 2010s-era Styles hadn't quite left his slouchy pre-fame self behind, of course. This fashion persona showed up in his off-duty wardrobe of trackies, hoodies and gilets – it's the look that Taylor Swift fell for. A photograph of the couple taken during their 2012 relationship sees Styles in hoodie and beanie hat, the kind of outfit that aims to blend in. Styles's behind-the-scenes clothes at this time often came from Jack Wills, a brand that – it's fair to say – has lost some of its sparkle these days but was quite the thing in the 2010s, even if the thing in question was non too subtle. Styles was photographed in a purple hoodie emblazoned with the Jack Wills logo in 2010: with a thumbs-up and a cheeky grin, he looked like the dictionary definition of a teenage dream.

This Styles era cannot, of course, be spoken of without mention of his hair. Something of an obsession for his growing fanbase (so much so that when Styles cut his hair in 2019, it became a topic of discussion on Twitter), this was its formative moment. The Styles barnet transformed from the wavy mop seen on *The X Factor* to a style that had the status of a legend: one half woodland sprite, one half rock god. The reputation of Styles's hair – a reputation that at this point in time almost outdid that of Styles – only increased during what shall henceforth be known as the Headband Years. Worn for a couple of years on the street and on stage, it may be the inspired accessory that cements the teenage Styles in his rightful place: as a hair icon of our time.

Thumbs up to an indie classic – the blazer and band T-shirt.
This was a formula that Styles made his own.

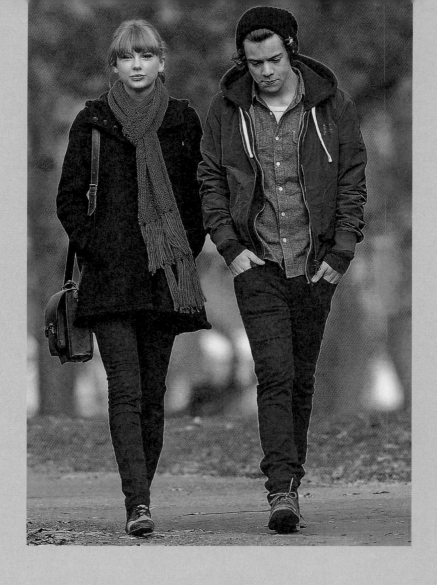

OPPOSITE The Jack Wills hoodie was an "it" item in the 2010s. Styles pairs his with other items typical of the era – copious bangles and trackpants.

ABOVE Styles's short-lived romance with fellow singer Taylor Swift meant twice the attention from the paparazzi – and outfits designed to help him blend in.

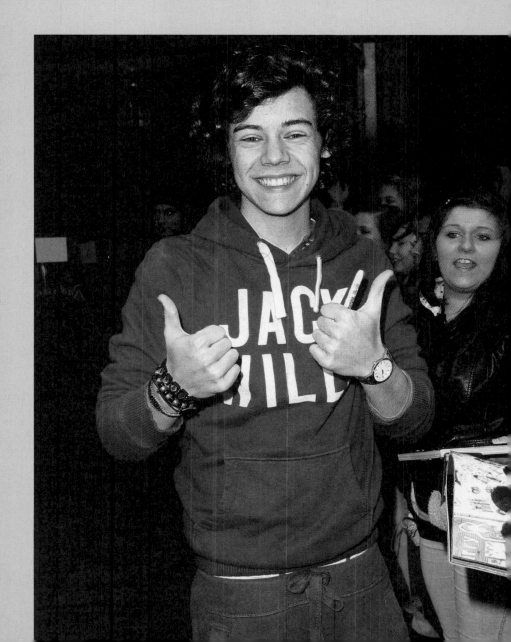

"The headband cements the teenage Styles in his rightful place: as a hair icon of our time."

A bit Mick Jagger, a bit off-duty dancer, Styles brings charisma to off-stage style.

On the front row

By 2013, Harry Styles meant more than One Direction. Sure, the band had just made *Midnight Memories* – the top-selling album of the year – but Styles had a new focus: fashion with a capital F.

Sartorially speaking, the singer had stood out from his bandmates since the 1D train set out from the station in 2010. But by 2013, Styles pinned his colours to the mast – he began to attend fashion shows. In September of that year he was seen at multiple shows at London Fashion Week, looking the part every time. For the Burberry show, he wore leopard print and his favourite skinny jeans, seated between Sienna Miller and Suki Waterhouse. Now very much one of the London cool kids, he was spotted having a giggle with Kelly Osbourne and Nick Grimshaw in the front row of insider shows like House of Holland and Fashion East, wearing a T-shirt by cult London designer Ashley Williams. Fashion always loves a celebrity spot but Styles was also signalling that he knew his stuff.

OPPOSITE Clad in a greatcoat, expensive sweater, skinny jeans and that headband, Styles was becoming a red-carpet regular to watch.

OVERLEAF Styles takes his seat on fashion's front row alongside Nick Grimshaw, Kelly Osbourne, Leigh Lezark and Alexa Chung.

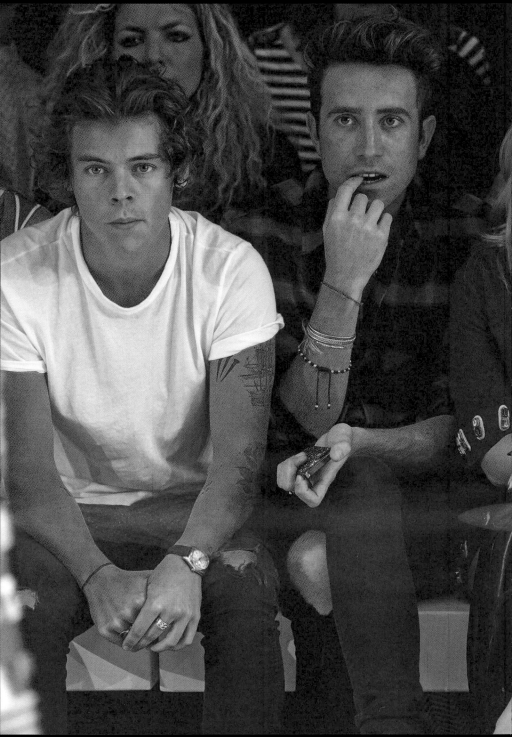

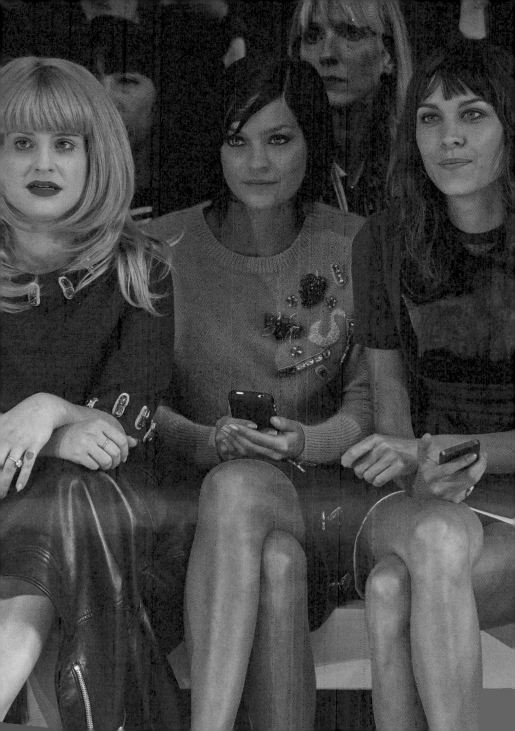

His savvy paid off by the end of the year. He was nominated for the British Style Award at the British Fashion Awards in 2013, and took the crown from three-time winner Alexa Chung. Walking the red carpet in a Saint Laurent jacket and polka-dot scarf, he made light of the honour, commenting "I've only got two pairs of jeans." The gentle humour continued in his acceptance speech. He quipped, "I actually didn't think anyone was allowed to win apart from Alexa" before thanking fans for his award.

By this point, Styles was firmly in with the fashion in-crowd. He attended Poppy Delevingne's hen do dressed as one of the brothers from wholesome pop band Hanson, in a blonde wig and plaid shirt, and was snapped at Chung's 30th birthday bash in a striped shirt and skinny jeans. He was even rumoured to be dating supermodels after a paparazzi shot showed him and Kendall Jenner sharing a car.

A man in black, and a worthy winner – Styles with his award at the British Fashion Awards in 2013.

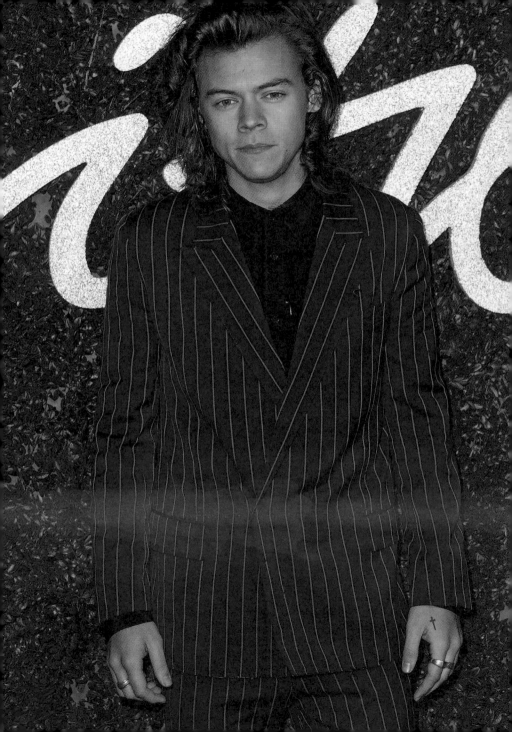

"By 2013 ... Styles had a new focus: fashion with a capital F."

Styles brought fashion-savvy looks to the British Fashion Awards
red carpet – including this striped Lanvin suit.

There was no going back now that the fashion horse had bolted. In 2014, Styles was a stalwart of high style and his clothes were getting bolder. At the British Fashion Awards that year, he wore a stand-out striped suit by Lanvin, his hair an artful mess. At elite party hotspot Annabel's, he picked a flamboyant ruffled shirt to amuse fashion royalty Kate Moss. For a party celebrating achingly cool fashion magazine *Love*, he donned an eye-catching printed suit. At a Burberry show, he chose a bottle-green suede trench and a low-cut jumper, which showed off his newly acquired swallow tattoos.

This sartorial experimentation also encroached on what Styles wore when he appeared with the rest of 1D. There was the open-necked patterned shirt he wore for the *Today* Show, and the Calvin Klein Obsession sweatshirt to strut his stuff on stage. The sweatshirt was a hot item in 2014 but when worn by Styles it was also, perhaps, a cheeky nod to how his fans increasingly thought of him.

Sitting at fashion's top table ... With the aid of a ruffled shirt and a boyish grin, Styles charmed fashion's big hitters, including Kate Moss.

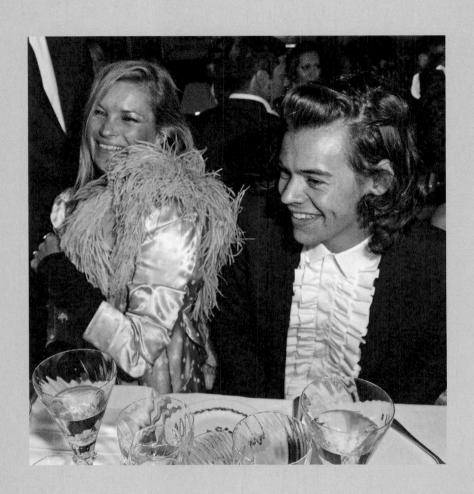

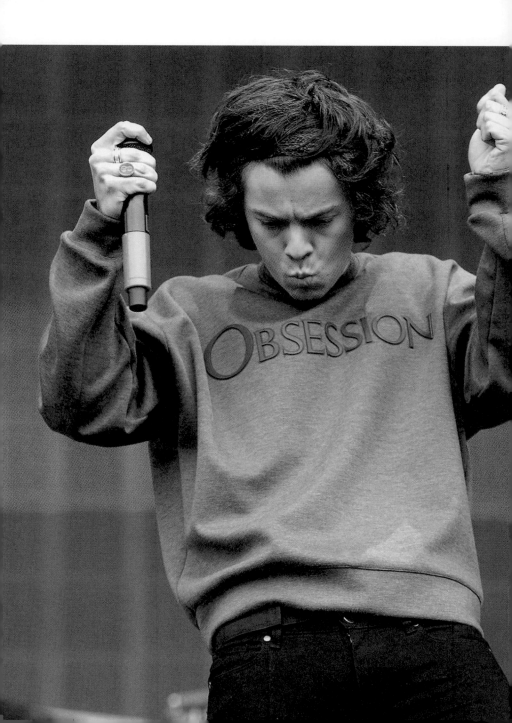

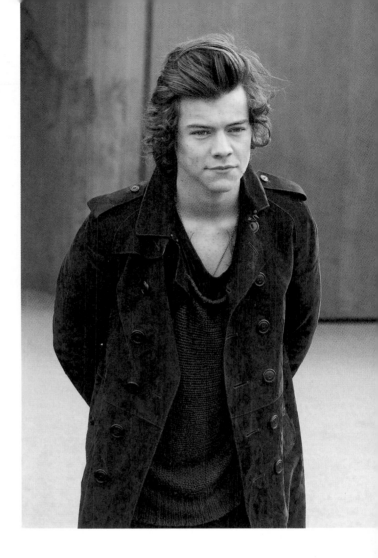

OPPOSITE "Obsessed" is often the word fans use to describe their devotion to Styles. It makes sense that he's wearing an Obsession sweatshirt, then.

ABOVE Wearing a trench coat to a Burberry show is sound style logic – but the fashion points are doubled when that trench coat is made of green suede.

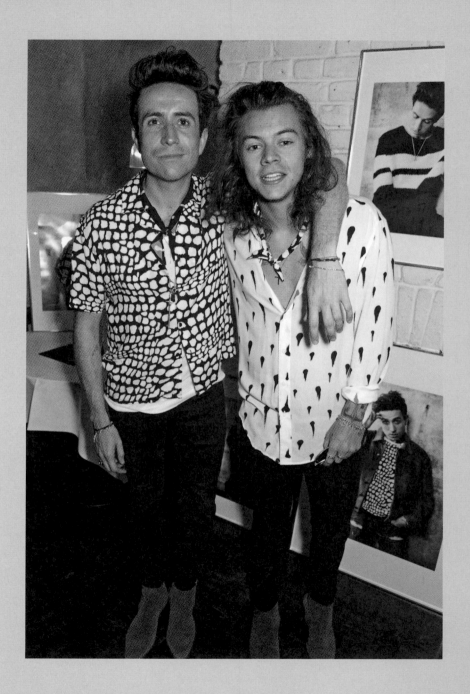

Zayn Malik left 1D in 2015. Now there were four, and Styles stood out like a sore thumb. If Styles and Malik had vied for the role as chief heartthrob, Styles now had that position all to himself. Of course, he took to it with gusto and brought to the role some of his newly emerged stylistic flair. Shirts were key – a zigzag-patterned Louis Vuitton number worn on the red carpet; a pink and white polka-dot statement piece worn on stage for Apple Music Festival in September 2015; a monochrome floaty design worn while hanging out with his BFF Nick Grimshaw. In this oversized creation, its sleeves rolled up, those swallows peeking out of the open neck, and with his hair now reaching way past his shoulders, Styles no longer looked like an inhabitant of the squeaky clean boy band world. The shirt looked great and it was also a sign of things to come.

Styles and his pal Nick Grimshaw have often dressed alike. Here they play twinsies in matching boots, jeans and monochrome shirts.

'It's only rock and roll (but he likes it)

Harry Styles has frequently been associated with Alessandro Michele, Creative Director at Gucci from 2015 to 2022, but Michele wasn't his first fashion love. That would be Hedi Slimane, the designer credited with bringing indie fashion classics like skinny jeans and biker jackets to the catwalk when he was at Dior Homme. When he took over at Saint Laurent in 2012, it was perfect timing for our hero.

Slimane's clothes suited Styles's evolution: he was, as the *Guardian* wrote, in his "Jagger period ... fashion filtered through *NME* rather than *GQ*." With his first foray onto the stage of *The X Factor* a distant memory, he was now in his early twenties, and a stalwart of the London fashion scene (he even met Jagger himself in 2015). He had a look that signposted aspirations to be a rock god, boasting long hair, tattoos and often a humblebrag white T-shirt, as a nod to the original era of rock and roll, the fifties. This look may even have inspired a lyric by Styles's ex-girlfriend Taylor Swift in a song aptly entitled "Style".

Once Slimane was in the hot seat at Saint Laurent, Styles took to wearing his designs regularly: a luxe military jacket in LA in 2014; a silk tour jacket for a performance on *Good Morning*

OPPOSITE Meeting Mick Jagger is major. Doing so while wearing a transparent leopard-print blouse and blazer? Even better.

OVERLEAF The odd man out ... By 2015, Styles had ditched boy-band style and was experimenting with rock and roll classics.

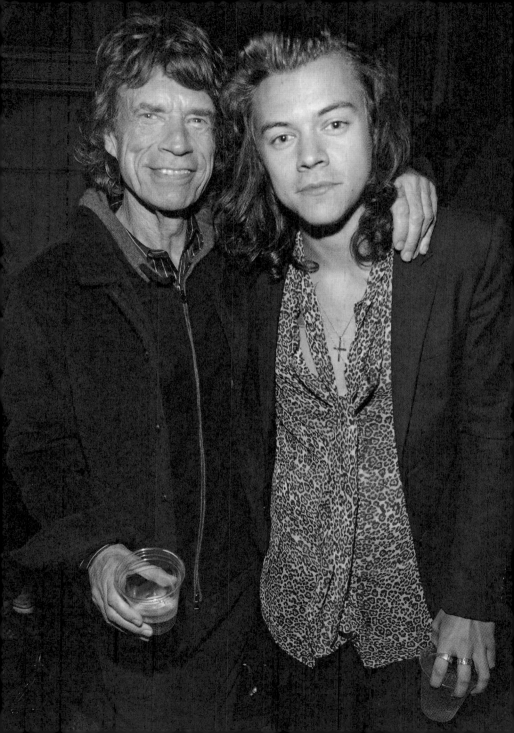

"*Styles's developing persona influenced every item in his wardrobe,* from onstage statement suits *to off-duty pieces such as a*

Gucci hoodie, worn with a classic suede jacket and skinny jeans. He might be successful, but he was also cool."

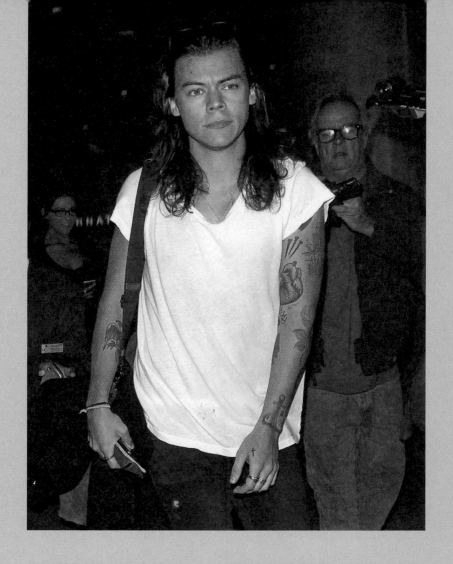

ABOVE The white T-shirt is a classic of urban cool – and Styles understood its power. See this outfit at Los Angeles International Airport in 2016.

RIGHT Aloha! Styles shows that he's up for print and pattern with a Hawaiian shirt. Add sunglasses propped in his curls and it's a look that says "summer".

OVERLEAF Styles's final performances with One Direction signposted a new look. This pink polka-dot shirt, worn open at the neck, is a case in point.

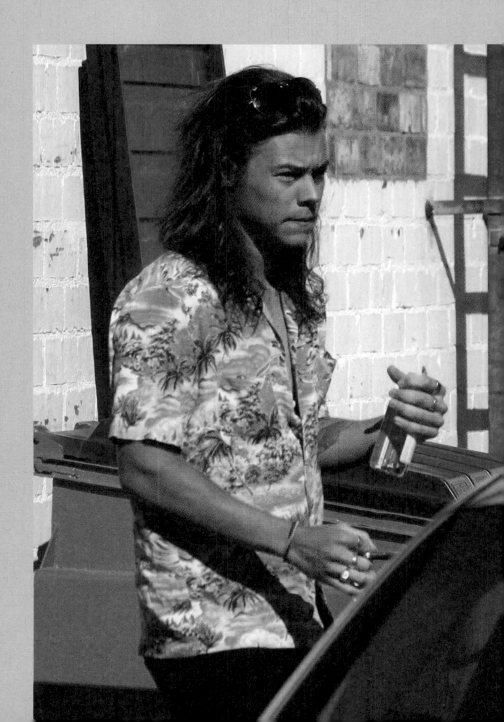

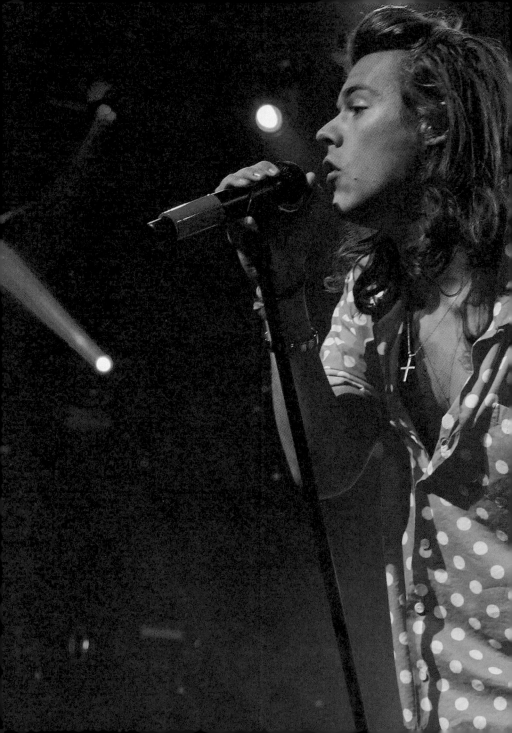

America in 2015 and that slouchy pink and white polka-dot shirt – an early take on the silky blouses he has since made into something of a signature. YSL was part of Styles's off-duty look too – Styles wore the brand's Hawaiian shirt (perhaps a tribute to his childhood hero, Elvis) when out and about in 2016.

He might have been in a boy band, but this look wasn't too much of a leap for Styles. He'd grown up with rock: his father listened to bands like Queen, Pink Floyd and the Rolling Stones. The star has the triangle from the cover of Pink Floyd's classic 1973 album *The Dark Side of the Moon* tattooed on his arm. He explained his childhood relationship with the record to *Rolling Stone*: "I couldn't really get it but I just remember being like – *this is really fucking cool.*"

Slimane, who in his youth had likewise pored over images of stars such as David Bowie and Mick Jagger, was a natural fit for Styles. In fact, the link between the two became so well established that when Slimane left the label in 2016, *GQ* ran an article entitled "What will Harry Styles wear now Hedi Slimane has quit Saint Laurent?"

Of course, Styles had other things to think about in 2016. After five years at the top and one breakaway member, One Direction were on what was dubbed an "extended hiatus" to focus on their own projects, something Styles had first mooted back in 2014. He started work on a solo album. This meant leaving behind the sanitized boy band world – complete with "cleanliness clauses" in his contract – for something that aligned with those rock star ambitions. Speaking to *Better Homes & Gardens* in 2022, he revealed that he had cried when he signed a solo contract containing no stipulations about his behaviour. "I felt free," he said.

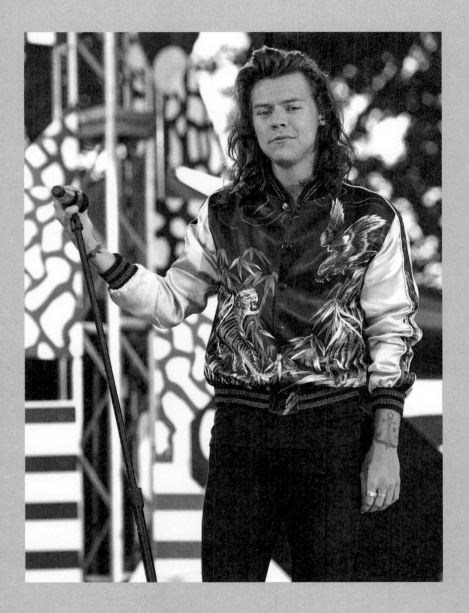

Hedi Slimane's Saint Laurent clothed Styles in the mid-noughties.
This silk tour jacket was worn on stage in 2015.

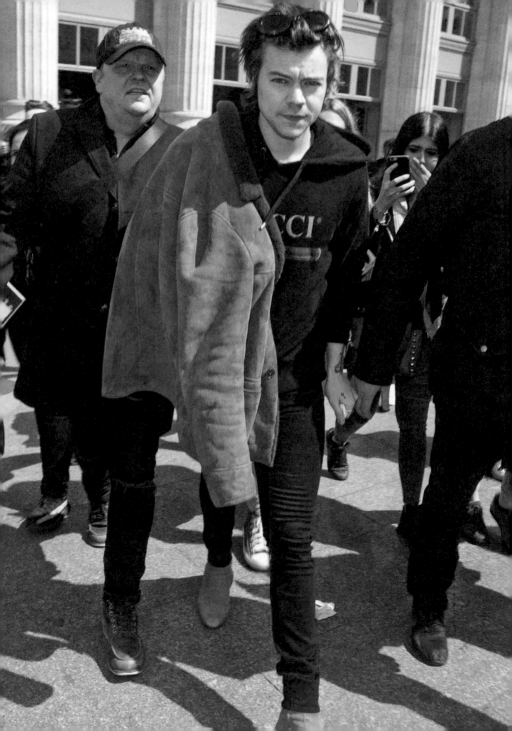

This was increasingly evident in the way he dressed and positioned himself in the public eye. Styles wouldn't release a note of his solo music until 2017, but his other love – fashion – allowed him, as it always had, to introduce hints about Styles 2.0. In September 2016, he was featured on not one but three covers for edgy magazine *Another Man*. Photographed by Alasdair McLennan and styled by Alister Mackie, this triptych is the first indisputable evidence that fashion loved Styles back.

In the pictures Styles is cute, retro and somewhat ironic in a pageboy wig and argyle jumper, Jagger-like in a military jacket and indie chic in an angora jumper and buckled choker. The issue also features an essay by his sister Gemma, which reveals touching details of her sibling's style journey. The piece includes a story about a teenage Styles stealing Gemma's straighteners to try – in vain – to tame those soon-to-be-famous curls. It's fair to say that Simon Cowell would not have approved. That, of course, was the point. As the *Guardian* wrote at the time, "Harry Styles proves the heartthrob is dead: long live the artthrob".

In *Another Man*, Styles was demonstrating that his appeal and credentials extended far beyond the pop charts. Styles's developing persona influenced every item in his wardrobe, from onstage statement suits to off-duty pieces such as a Gucci hoodie, worn with a classic suede jacket and skinny jeans. He might be successful, but he was also cool. This formula – one that Styles seems to navigate naturally – no doubt filled his former bandmates with something like envy. It's a quality that's been in evidence ever since. What can we say? You've either got it or you haven't.

Gucci, skinny jeans and a suede jacket ... this is a classic mid-noughties Styles outfit, worn to stride into a new era.

Pushing the

CHAPTER 2

Boundaries

Big boy's blouses

Without One Direction, Harry Styles needed a new look – and a new sound. Both were accompanied by a specific item, one that pushed at the status quo but in a way that's ever so gentle. Enter ... the blouse. For his first solo interview with *Rolling Stone*, conducted on the release of his eponymous solo album in 2017, Styles was photographed wearing a black brocade suit and red satin pussy-bow blouse. A year after Donald Trump notoriously said that he felt entitled to grab women "by the pussy", the outfit choice felt pointed and a bit rebellious – because it wasn't entirely, totally masculine. It certainly wasn't what would be expected of a man positioning himself as a serious musician beyond his past in a boy band. And it was all the more charming for it. Styles had played with the idea before he went solo, wearing a chiffon leopard-print blouse for a gig and a louche black satin number on the red carpet in 2015. But post 1D, the blouse became a bona fide Styles signature piece.

A boy with a pearl earring, ruffles, lace and heels ...
At the 2019 Met Gala, Styles offered a new take
on red-carpet dressing for men.

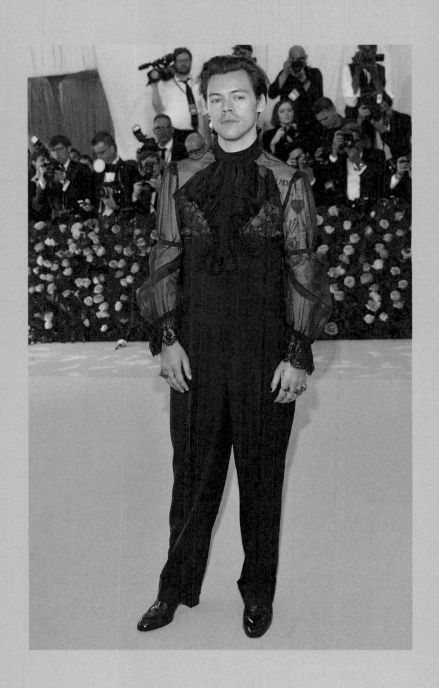

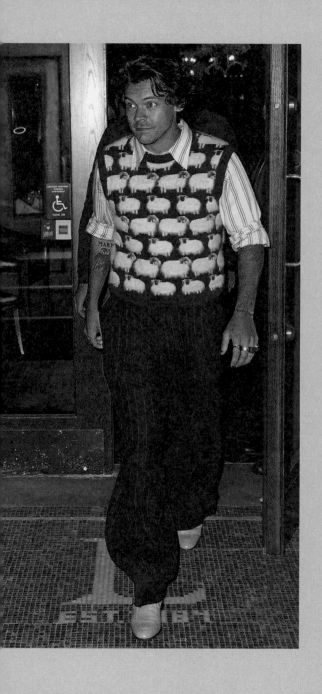

Styles achieved peak blouse at the Met Gala in 2019. One of the three co-curators of the event and embracing the "Camp" dress code, Styles was dressed by his frequent collaborator, Gucci designer Alessandro Michele, in a sheer black blouse adorned with a gigantic frilled bow, puffed sleeves and lace cuffs. Combining a blouse with high-waisted black trousers, a Cuban heel and a pearl earring, Styles was both incredibly modern – "Harry Styles freed the nipple on the Met Gala red carpet," wrote *Vogue* – and had the air of a long-forgotten prince, or at least a boy with a pearl earring. As his stylist Harry Lambert said, "The look, I feel, is elegant. It's camp, but still Harry."

Speaking on the night about his outfit and the event's camp theme, Styles said his choices were about fashion as "enjoyment, fun and no judgement". This is a formula that he has continued to perfect. Interpretations range from a blouse underneath a tank top – one made by Rowing Blazers covered with sheep, *à la* Princess Diana, made the internet lose its mind in 2019 – to constant updates on the beloved item itself. In the video for 2020's "Falling", the blouse takes centre stage. Soaked with water, it has something of Mr Darcy in *Pride and Prejudice* about it. Older references like this feel right in Styles's fashion world – in fact, these blouses position him amid a rich history of dandies in frills, dating all the way back to Beau Brummell in the eighteenth century.

Counting sheep ... and fashion moments. This tank top brought a collective chorus of "awwwwww" to the internet in 2019.

Like Brummell, Styles likes to perfect a silhouette and the combination of high-waisted sailor trousers and a glitzy blouse is a favourite. This is an outfit he wore three times in 2019 – on stage with Kacey Musgraves in Nashville, for the video of "Lights Up" (also involving water) and finally on the cover of *Fine Line*, his second album. A blouse is clearly his perennial pick for the cover of a new album and a favoured way to signal a mood. If *Fine Line* was all about exaggerated movements and a smidgen of drama, *Harry's House* – released in 2022 – was a more vulnerable, subdued affair. See Styles's smocked blouse, by womenswear designer Molly Goddard, worn with wide-legged jeans and plimsolls. The look feels sweet and almost childlike.

The blouse remains an item that's in heavy rotation for Styles now – a predilection he acknowledges, embraces and even sends up just a little. When he inducted his friend Stevie Nicks into the Rock and Roll Hall of Fame in 2019, he said, "She's always there for you. She knows what you need – advice, a little wisdom, a blouse, a shawl; she's got you covered."

Ahoy there! Sailor trousers and shine work as a formula on stage in Nashville with Kacey Musgraves in 2019.

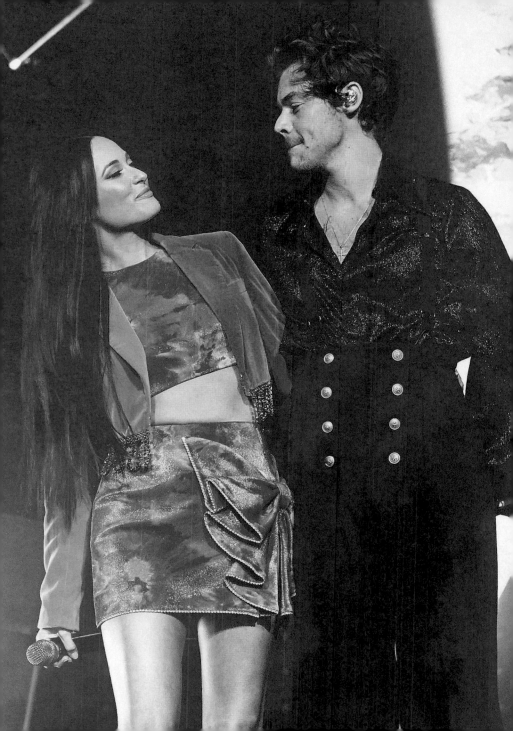

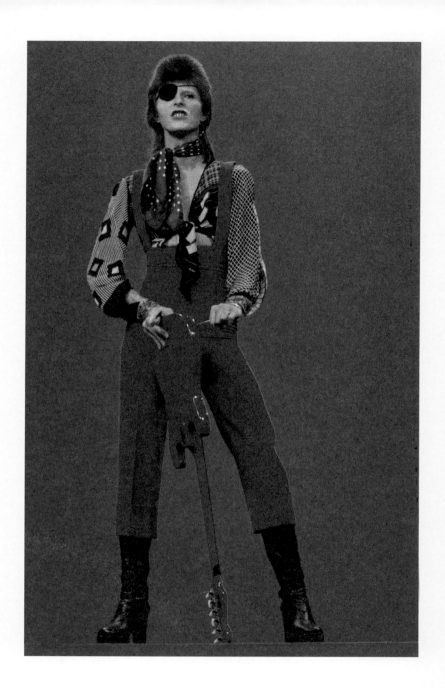

Twenty-first century boy

Speaking about Styles's style in 2019, Elton John – no slouch himself when it comes to fashion – compared the peacock look of the newer star to the aesthetic preferred by some of his heroes. "It worked for Marc Bolan, [David] Bowie and Mick [Jagger]. Harry has the same qualities." High praise, of course – this is a lineage that Styles strives to be part of. Styles has clearly been influenced by these legends when it comes to his music, but he's also spoken about taking them as role models when it comes to being a full-package star, someone who cares about what he looks like as well as what they sound like. "You can never be overdressed. There's no such thing," he told *Vogue* in 2020. "The people that I looked up to in music – Prince and David Bowie and Elvis and Freddie Mercury and Elton John – they're such showmen."

Even though he neglects to mention him here, it's Marc Bolan that Styles is most often compared to – partly because they share the genetic blessing of seriously great hair but also because of the feather boa. Bolan made the item a key element of his glam rock-tastic look in the sixties and seventies before his life and career were tragically cut short. He was upfront about how important appearance was to stardom. Talking to Cameron Crowe for *Creem* Magazine in 1973, Bolan said, "95 percent of my success is the way I look."

With his fearless approach to fashion – and penchant for jumpsuits – there would be no Harry Styles without David Bowie.

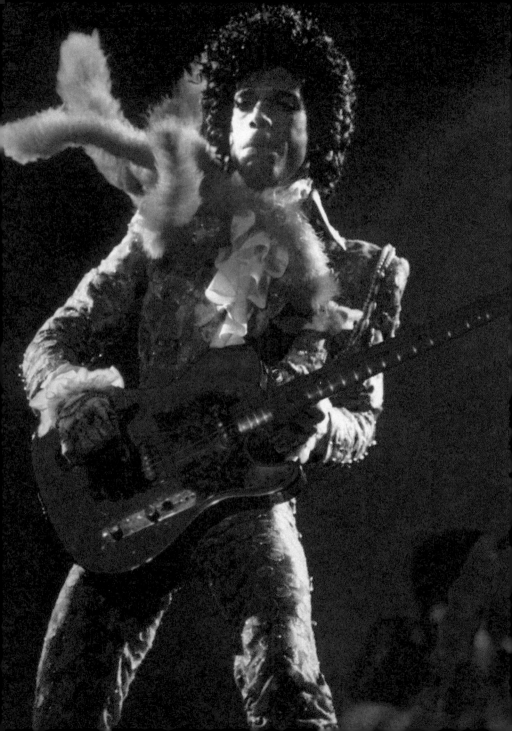

"*You can never be overdressed. There's no such thing.*"

HARRY STYLES

An opulent dresser and a consummate showman, Prince would be a positive influence on any young musician. Add a feather boa and Styles is sold.

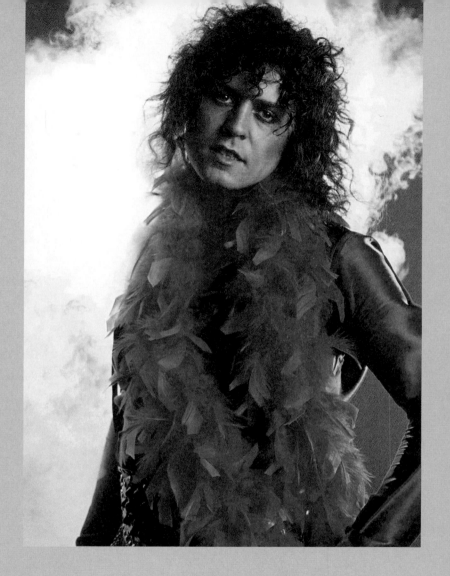

ABOVE Glam incarnate – Marc Bolan in a feather
boa in 1971. Looking at this image, there's no doubt
Bolan has been an influence on Styles.

OPPOSITE Styles in his red-carpet boa at the Grammys in
2021, worn with a tank top and brown velvet trousers. It's
clear a seventies mood board was behind this look.

And what a look it was. If Bowie used clothes to conjure up characters and Prince used them to scandalize and seduce in equal measure, Bolan was the one to bring sartorial pleasure, excess and fun into the jumpers-and-jeans world of the sixties music scene. If you think about it, Styles was similarly something of an outlier. His solo career thrust him into a musical landscape that liked its fashion somewhat subdued. See, for example, Kendrick Lamar on the cover of his acclaimed album *DAMN*, clad in a simple white T-shirt, or Styles's ex Taylor Swift photographed for *Reputation* modelling a holey sweatshirt. Styles, meanwhile, tugged satin and pussy-bow blouses out of the dressing-up box. His look was a sign of things to come, a reassessment of fashion as fun, a cornucopia of looks to enjoy. Musicians ranging from singer and rapper Lil Nas X to synth-pop star Olly Alexander now take a similar approach.

Styles harks back to Bolan's seventies glam-rock era, when male musicians wore make-up, knee-high boots and as much shiny fabric as they could get their hands on. At the time, acts like Bolan, Bowie and Roxy Music were questioned for wearing clothes that were seen as "for women" and choosing to dress this way marked them out as non-heteronormative. Nearly fifty years have passed but Styles has thinly veiled homophobia thrown at him for similar reasons even now. Always clear that he doesn't talk about his private life – and that his sexuality is his own business – he pushes back against these comments and against the idea that anyone should be judged for how they dress. Talking about his outfits with the *Guardian* in 2019, he said he doesn't wear anything "because it makes me look gay, or it makes me look straight, or it makes me look bisexual, but because I think it looks cool."

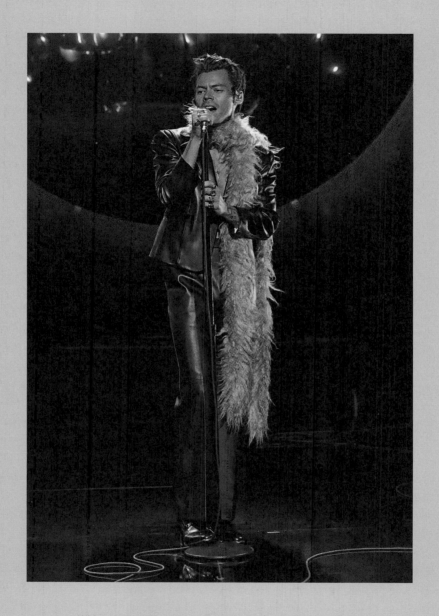

With a quick outfit change, Styles takes to the Grammys stage,
this time decked out in a green boa. Bolan would approve.

The feather boa has become Styles's nod to those who came before him – an item that's pure fun and that also, on a man, quietly questions ideas of who can wear what. For his appearance at the Grammys in 2021, he wore not one but two. On the red carpet, it was a lilac number, set off perfectly by the primrose yellow of his blazer (and a face mask, as the event took place at the height of the pandemic). On stage, to sing "Watermelon Sugar", a green boa. Worn with a black leather suit with nothing underneath – and ditched halfway through – this was a rock star accessory used in a way only a rock star knows how (appropriately, Styles won Best Solo Performance). Bolan, a consummate performer in his own time, often clad in a boa, would have been proud.

Dressing the part

Harry Styles isn't just loved and adored by fans and appreciated by fashion and music insiders for his sonic and stylistic choices. Oh no. He's also a pop star who makes history. Such as when – in November 2020 – he became the first male star ever to have a solo *Vogue* cover. Styled by Camilla Nickerson, photographed by Tyler Mitchell and interviewed by Hamish Bowles, Styles received the full US *Vogue* treatment. The cover would have hit the headlines whatever he was wearing but add the fact that he donned two gowns and two kilts in the shoot and the media, online and off, were kept busy for days. "Cause of death: Harry styles vogue photoshoot," wrote @freddcury on Twitter.

A Scottish gig, you say? In 2018, that called for a kilt. Yes, it's national dress, but it's also an early example of Styles bringing the skirt into menswear.

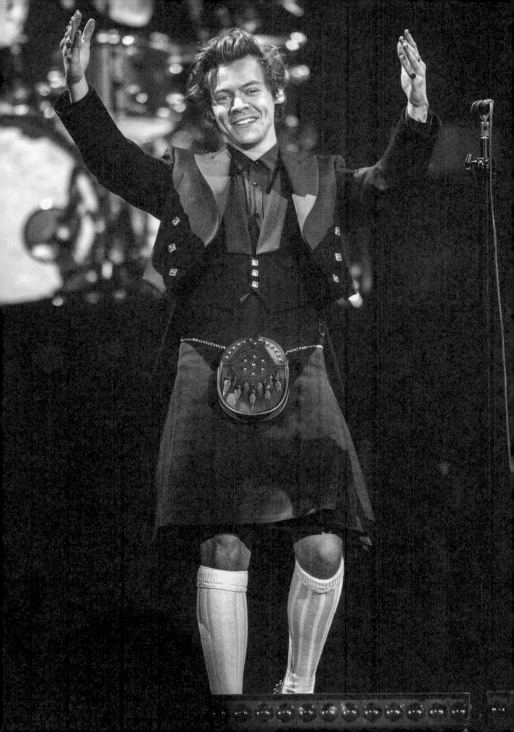

Refinery29, meanwhile, described the release of the images during a surge in the pandemic as "an act of end-of-the-week kindness we needed".

The coverage wasn't all positive. Conservative pundits identified the cover – and Styles – as a symbol of all they felt was wrong with gender politics in the twenty-first century. "Bring back manly men," tweeted Candace Owens, the commentator who later became became notorious for wearing one of Kanye West's White Lives Matter T-shirts at his 2022 fashion show. Ben Shapiro backed her up, writing, "Anyone who pretends this is not a referendum on masculinity for men to don floofy dresses is treating you like a full-on idiot."

Styles, however, has long experimented with what he wears below the waist: he wore a kilt for an appearance in Scotland in 2018 and a tutu on *Saturday Night Live* in 2019. Another notable moment was his shoot with *Dazed & Confused* magazine in 2021, which featured a skirt suit. His resistance has largely taken the form of action rather than words but he did put his point of view across to *Vogue*. "When you take away 'There's clothes for men and there's clothes for women,' ... you open up the arena in which you can play," he said. As actor Jameela Jamil tweeted in Styles' defence: "Manly is whatever you want it to be."

Frills, smocking and layers ... Styles' Gucci gown worn in *Vogue* is now so famous it was exhibited at the V&A in 2022.

Glossy photoshoots might dominate the headlines but Styles challenges the gatekeeping around clothing beyond magazine covers, in lots of different, more subtle ways. He typically wears tailoring for the red carpet but adds elements that play with gender roles, including, sometimes, make-up. Pearls are now a signature accessory for Styles: he wears them with pretty collars, knitwear and Mary Janes, things more often associated with a "little old lady" trope than a rock star. He's worn this look everywhere from the BRITs in 2020 to *The Howard Stern Show*, a space more often occupied by the kind of masculinity that Owens might approve of. Styles also carries Proper Handbags – the kind, again, that might typically be favoured by that "little old lady". He's sported classic Gucci designs, with their immediately recognizable bamboo handles, with a certain amount of glee. Nail varnish – sometimes adorned with smiley faces, sometimes in a sweetbox of pastel colours – is another endearing detail of a typical Styles ensemble. He's been wearing it since 2015, with celebrity manicurist Jenny Longworth often doing the honours.

The way Styles dresses and the attention it attracts has been criticized on the grounds that he's seemingly a straight man playing with gender and largely being celebrated for it, while members of the LGBTQI+ community have been threatened and stigmatized for making the same choices. American actor Billy Porter, who wore a dress to the Oscars in 2019, said to the *Sunday Times* about the *Vogue* cover, "All he has to do is be white and straight". While Porter later apologized to Styles – "It's not about you. The conversation is not about you," he said on *The Late Late Show* – tension remains around

Pearly King ... Styles brings his favourite accessory to the BRITs red carpet. The suit, sensible sweater and Mary Jane shoes add up to a subtly subversive look.

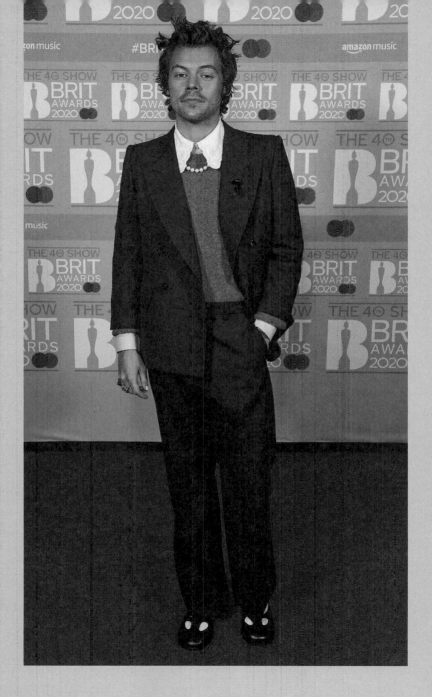

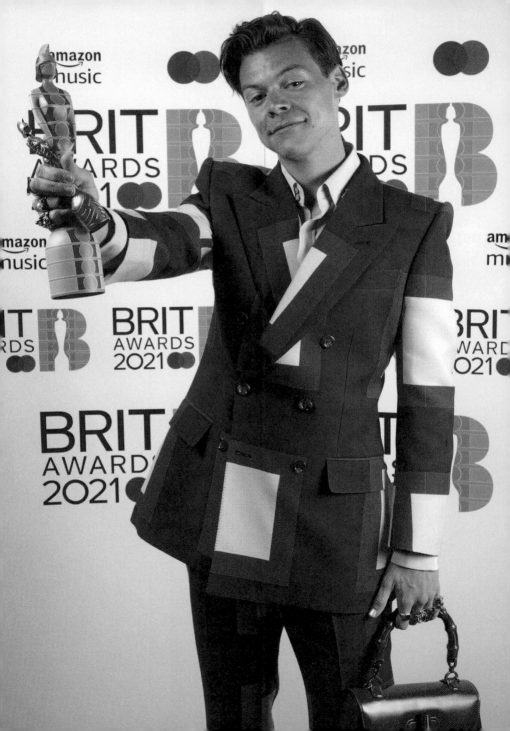

this issue. Styles, for his part, has made gestures in support of the LGBTQI+ community throughout his solo career, carrying a flag that read "Make American Gay Again" on stage during Trump's presidency and speaking out about making concerts more inclusive. In 2018, he was named LGBTQ Advocate by *Gay Times*.

The star's fashion choices have indisputably opened up ideas of what might be the norm for male attire these days. Skirts are on the cusp of becoming a widely accepted element of the male wardrobe, worn by stars like Brad Pitt but also by non-famous men. In 2022, Highsnobiety, a website known for its streetwear coverage, ran an article entitled "Skirts for men might finally be here to stay". And then there's nails. Styles launched his beauty brand Pleasing in 2021 and in his wake, other male celebrities, including Machine Gun Kelly and Tyler, the Creator, have also announced nail varnish collections.

Speaking to the *Guardian* in 2022, youth culture analyst Alex Goat said Styles' high-profile openness is part of what makes him such an icon for Generation Z. "I have no doubt he's given others the confidence to express who they are and who they want to be," she said. Moments like Styles's *Vogue* cover, and his use of pearls and nail varnish, are part of that. Styles's 2021 appearance for Harryween – his take on Halloween, taking place at Madison Square Gardens since 2019 – would only have underlined that message. He went all out in a dress similar to the one worn by Dorothy in *The Wizard of Oz*, complete with ruby slippers.

How best to show off your BRIT? Prints, a double-breasted jacket and, of course, a bamboo-handled handbag.

ABOVE Details are everything – that's why Styles makes
sure he's stylish right down to the tips of his fantastic
fingernails, as seen here at a Gucci show in 2019.

OPPOSITE It's not always designer accessories clutched in
Styles' hands – he loves to support fans' causes, bringing
their flags and signs on stage, as in this snap from 2018.

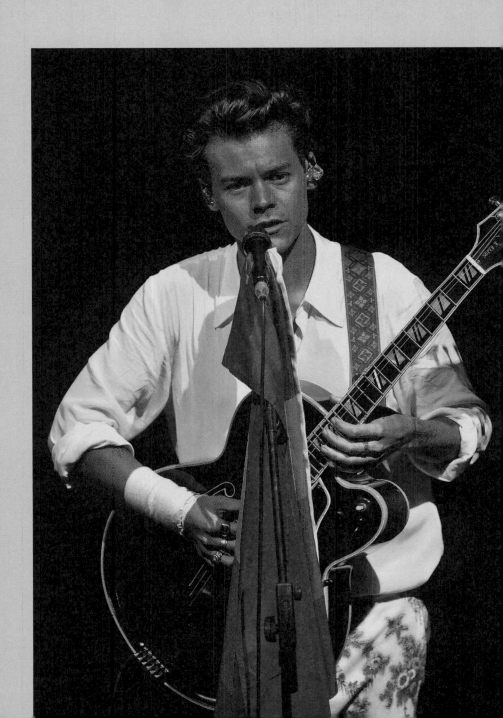

Jump to it

In 2022, the most streamed song was Harry Styles's "As It Was", played more than 1.6 billion times globally. Sure, the song is a breezy atmospheric earworm featuring Styles's signature breathy vocals, but the video also made it a hit. Or, to get granular, the jumpsuit that appeared in said video. Cherry red, featuring sequin stripes and flared legs, it clings to Styles whether he's walking backwards through London's Barbican Centre or throwing shapes with a dance partner dressed in a matching blue version. Watched nearly 460 million times on YouTube at the time of writing, the video and its fashion moment has influenced the general public. In the week it was released, there was a 212 percent rise in searches for "men's jumpsuits" online.

Styles's jumpsuit was created by Paris-based designer Arturo Obegero from deadstock material. Speaking to *GQ*, Obegero explained that rock gods Mick Jagger and David Bowie were on the mood board. Both these men were partial to a jumpsuit. In fact, you could say that Styles has taken his inspiration from them and run with it. At the present moment in time, Styles absolutely owns the jumpsuit. Think of early examples: his adorable 1D onesie; the Charles Jeffrey pinstripe design worn on *The Late Late Show* in 2017. Then there's the incredible glittery number, worn open to the waist, for

OVERLEAF Silver bullet: Harry Styles, winner of Album of the Year award, on stage in a silver Gucci jumpsuit at the Grammys in 2023.

"*In the week that the 'As It Was'* video was released, there was a *212* percent rise *in* searches for 'men's jumpsuits' online."

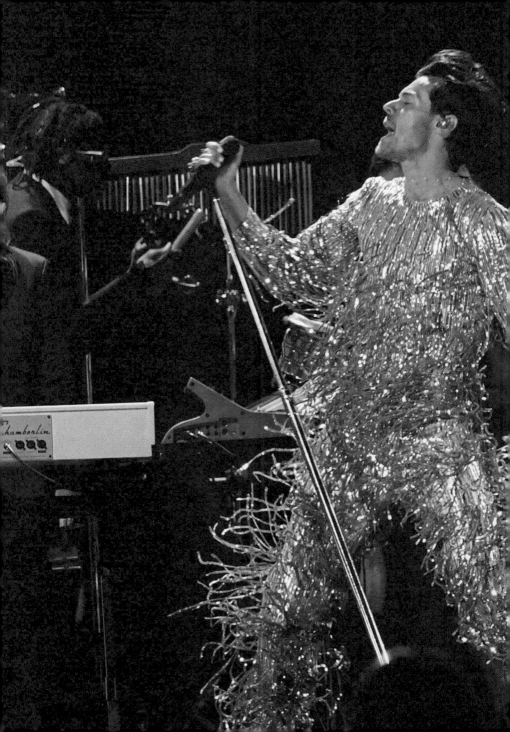

UK radio station Capital's Jingle Bell Ball concert in 2019, and the Obegero number worn for Radio 1's Big Weekend three years later. The glitter look (which is two pieces but looks like a jumpsuit) may have been a nod to his hero Elvis, who was also known for wearing jumpsuits, accessorized with chest hair, at his Vegas residencies in the seventies.

Jumpsuits have emerged from the Styles wardrobe for many high-profile occasions. There was the lace jumpsuit, complete with gloves, that he wore for the BRITs in 2020, an outfit sure to grant him top fashion billing in any future New Romantic revival. For his Coachella debut in 2022, he was the embodiment of a disco ball in a jumpsuit entirely covered in sequins. Worn alongside Shania Twain's equally sparkly frock, it's fair to say that the outfit lit up the festival. At the Grammys in 2023, he repeated the trick – this time wearing silver.

Such is Styles's influence that his outfits make waves across the internet. A candy-striped JW Anderson jumpsuit, worn for a live performance on the *Today* Show in May 2022, was a hit on social media, where it was compared to caterpillars and actual candy canes. Styles himself downplayed the outfit with typical nonchalance. "Well, it's early, so I wanted to be comfortable," he said on the show. "I thought, sleeping bag, babygro, I'm going for comfort. And I thought I could soak up some of the rain with this." Practical *and* a showstopper? On Styles, there really is nothing a jumpsuit can't do.

OPPOSITE A big outfit for Radio 1's Big Weekend in summer 2022. Styles wore a custom-made jumpsuit created by Arturo Obegero, who also designed the one worn in the video for "As It Was".

OVERLEAF Elvis – or Harry Styles – is in the building. A glittery outfit worn for the Jingle Bell Ball in 2019 paid homage to the king of rock and roll.

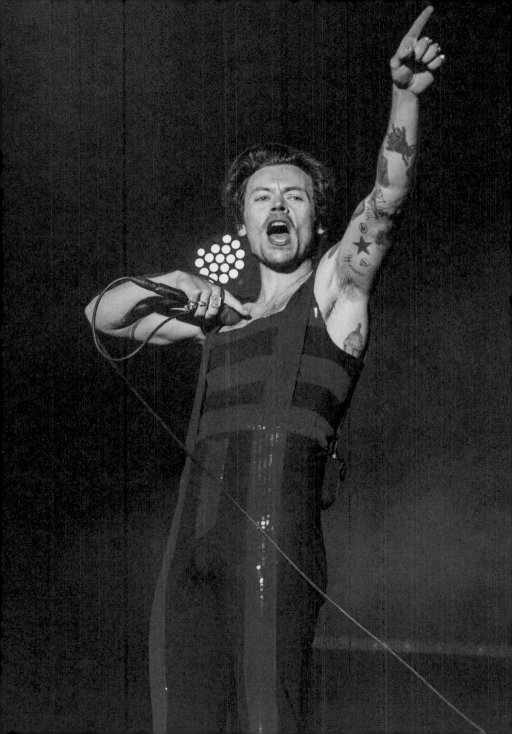

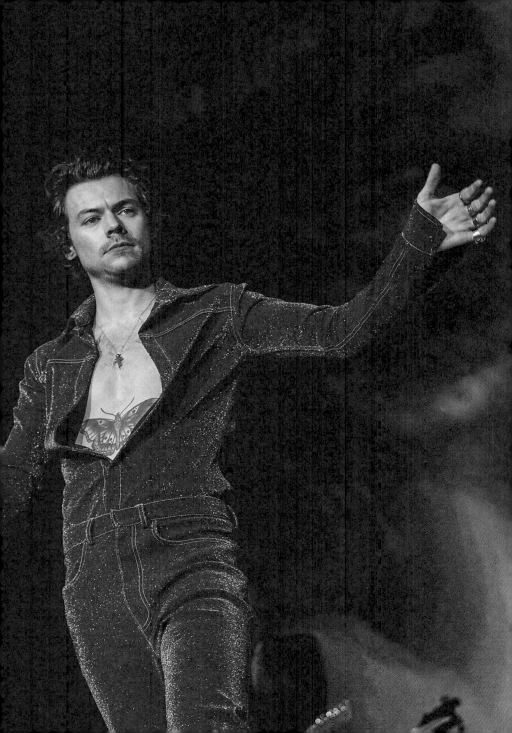

"*For his* **Coachella** debut *in 2022, he was the* embodiment of a *disco ball in a* **jumpsuit** *entirely* covered in sequins."

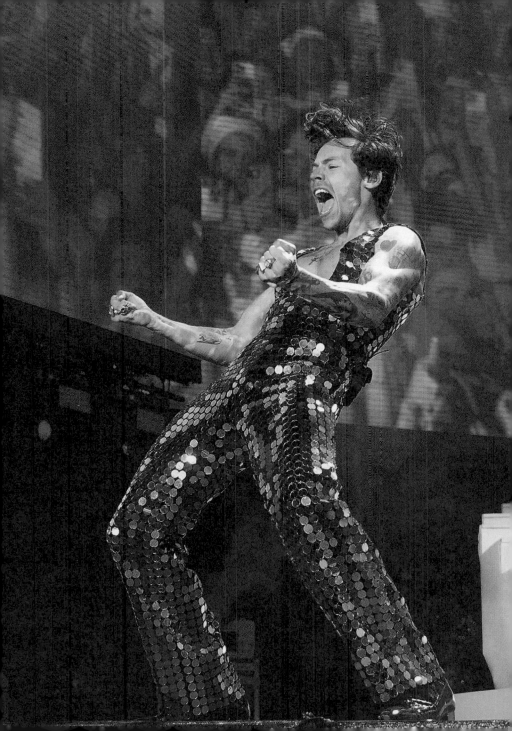

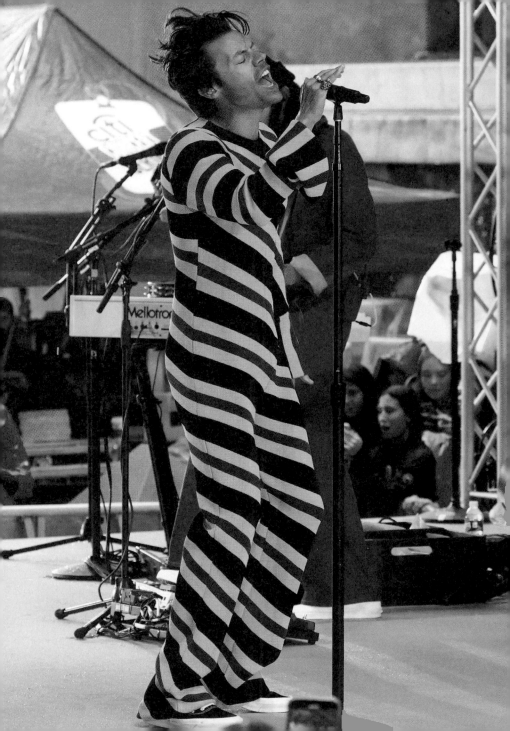

"I thought, sleeping bag, babygro, I'm going for comfort."

HARRY STYLES

Resembling, according to the internet, a caterpillar or a candy cane, Styles's JW Anderson jumpsuit was all kinds of fabulous.

In the pink

When he was thinking about what Harry Styles stood for, once he no longer stood for 1D, the musician had one colour in mind: pink. The word was the working title of his first solo album and on the mood board for its cover design. While the album ended up being called *Harry Styles* and pink became the background colour, overshadowed by Styles's naked back, it remains a hue that defines who the artist is. Speaking to *Rolling Stone* on the eve of the album's release, Styles quotes Paul Simonon from The Clash and his pronouncement, "Pink is the only true rock and roll colour."

It's certainly rock and roll in Styles's hands. The colour has played a key role in his fashion journey, dating back to that polka-dot sprinkled, oversized shirt he wore as part of the 1D line-up in 2015. He has since used the colour to introduce a new era: soft, but also bold. For one of his first appearances to promote his debut album, on the *Today* Show, he wore a pink suit designed by tailor Edward Sexton. As *Teen Vogue* put it, the suit "broke the internet" with one Twitter user commenting – in all caps – "HARRY STYLES IN A PINK SUIT WAS ALL I EVER NEEDED IN LIFE AND I DIDNT KNOW UNTIL NOW".

Truly rock and roll – a pink suit was just the thing for a post-One Direction Styles. Bold, simple and signposting a new era.

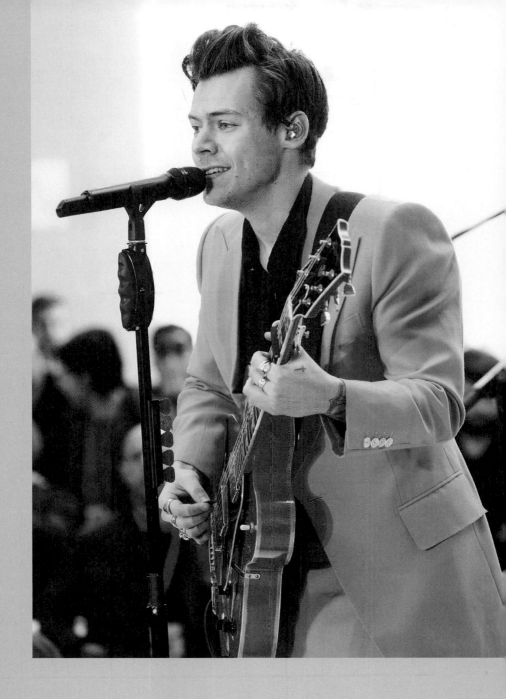

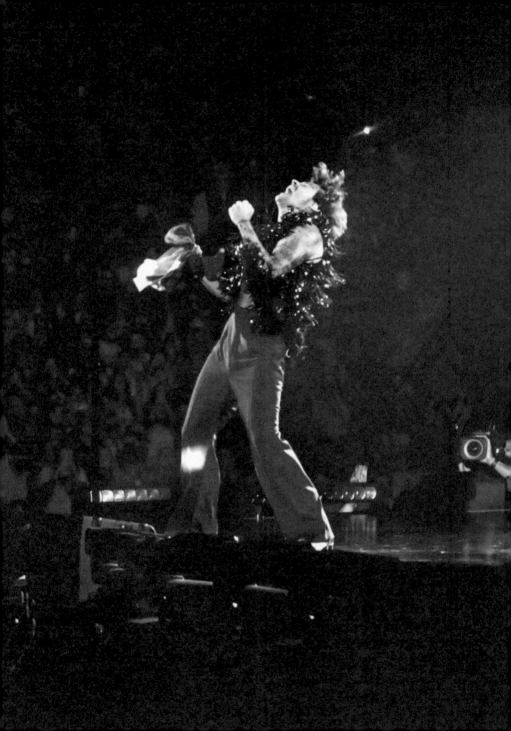

Men wearing pink has often been associated with queerness. The arrival of the cover of *Fine Line* in 2019 saw fans debating Styles's outfit. He wore a hot-pink blouse and white trousers, posing in a bubble that swirled with soft pinks and blues. Styles's use of the colours that appear on the bisexual flag was seen as a clue about the star's sexual preferences. Whatever the album cover was intended to signify, it's pretty clear that Styles likes pink. After the *Today* Show performance, he's worn more suits in the colour, including a beautiful embroidered number on tour in 2018. He has taken to wearing rosy-hued accessories too, such as the pink cowboy hat he wore on stage in Texas in 2021.

It's not all for show, either. In an interview for *The Face* in 2019, Styles details the acquisition of a pair of rare pink metallic cowboy boots made by Saint Laurent that he hasn't ever been photographed in. Describing them as "super-fun", he wears them, he says, "to get milk" (a scenario that you'd think would likely break the internet once again). He was also photographed in New York during the pandemic wearing pink, this time a visible-from-space neon shade on a sell-out hoodie from buzzy sweats brand Pangaia, accessorized with a cap that he picked up at his friends Katie and Conor's wedding. The sartorial moment received approval from *Vogue*, who wrote, "A trending hoodie *and* a sentimental hat? Sure beats our day-off look."

Starting the Love on Tour tour in style – wearing a pink sequin waistcoat and matching pink trousers. Thank you, Gucci.

"*Pink* is the only true *rock and roll* colour."

**PAUL SIMONON,
THE CLASH**

An update on the country crooner – bring the guitar and the
embroidery, but add a very rosy shade of pink.

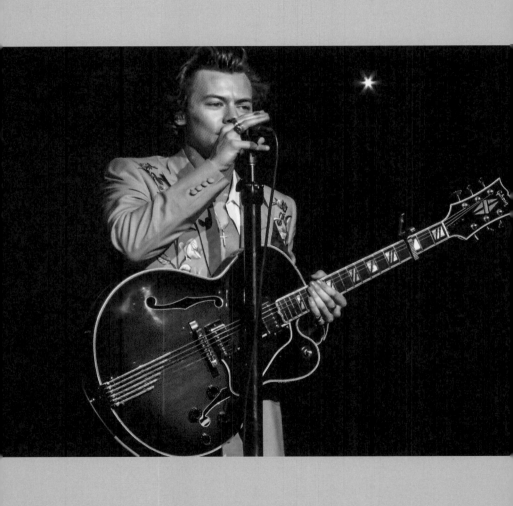

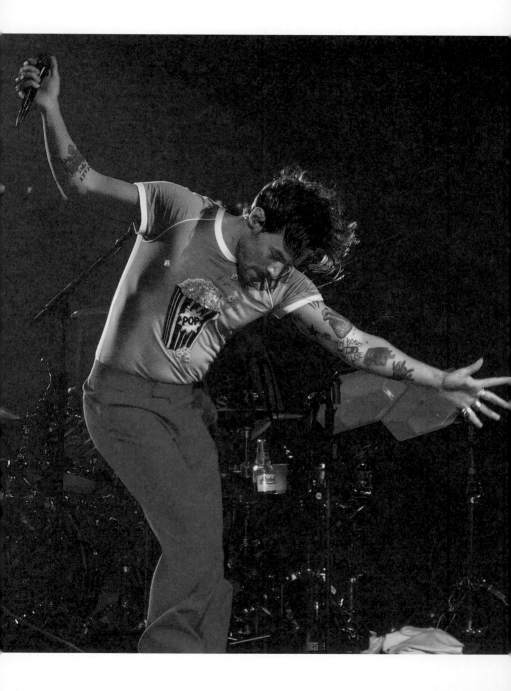

Styles continues to wear pink for his days "on", too. See, for example, a pink sequin waistcoat and pink trousers on tour, or his performance at Coachella in 2022. After his sequin-covered duet with Shania Twain, the appearance of Lizzo the next weekend prompted an entirely different kind of look. Styles and Lizzo had performed together before, to speculation from fans that their on-stage chemistry also translated into a connection behind the scenes. While they remain platonic, the pair showed just how in sync they were by wearing matching pink outfits for this performance. Styles's feathered coat, in two equally edible shades of sugar pink, clashed delightfully with Lizzo's, and both singers wore metallic pink trousers. With the addition of a pink cowboy hat and a waistcoat, the result was a rose-tinted symphony.

Styles's championing of pink has likely influenced the increasing popularity of the colour. Pantone named Viva Magenta, a purply shade of pink close to that worn by Lizzo and Styles, as their colour of 2023. The brand's description of "a pulsating colour whose exuberance promotes a joyous and optimistic celebration, writing a new narrative", could be a manifesto for Styles's long-standing preference for pink.

OPPOSITE How do you signal that you're in the party mood? Wear pink party pants, of course. Styles did just that in Palm Springs in 2023.

OVERLEAF Pretties in pink – Styles and Lizzo upped their onstage chemistry at Coachella in 2022, clad in matching outfits.

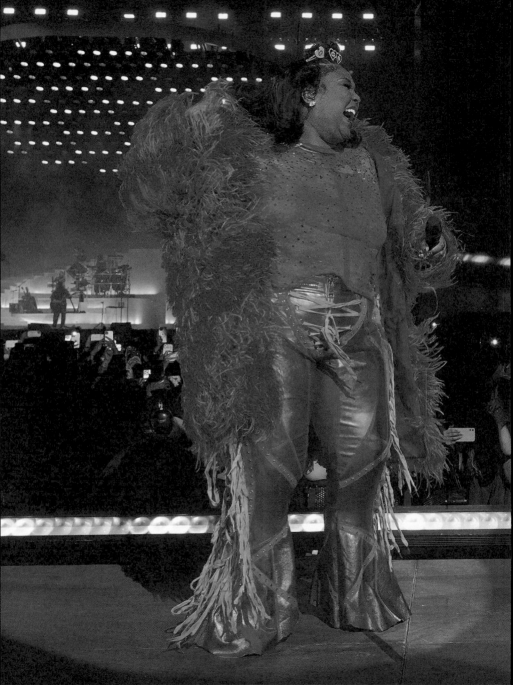

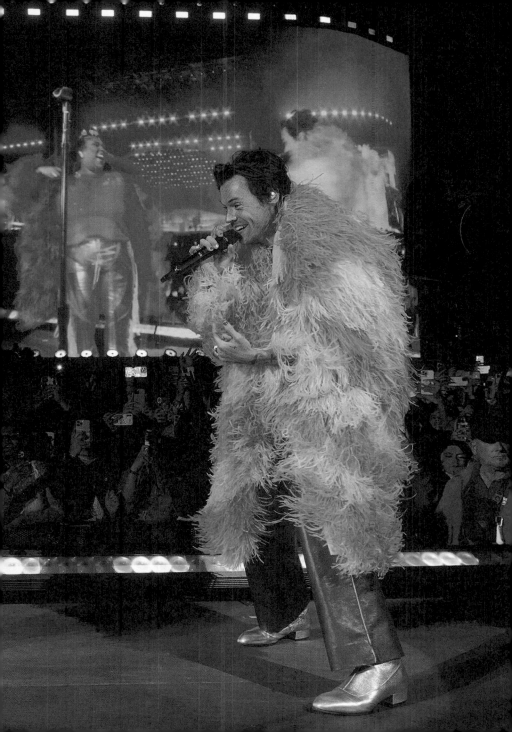

Designers, Stylists

CHAPTER 3

and Design

Sue – and Susan

Harry Styles might be the face of a style revolution but there's another Harry helping out behind the scenes – stylist Harry Lambert. The two Harrys call each other Sue (Styles) and Susan (Lambert) to avoid confusion (apparently). They began working together in 2014, at a formative moment for Styles. He was still in 1D but fashion-wise, he was already moving on, wearing boldly patterned shirts for appearances on the *Today* Show and leopard print to London Fashion Week. But Lambert was the missing piece of the puzzle – the man to push him further. The stylist gave Styles the key to an electric new look.

Speaking to *Vogue* in 2020, Styles remembered how out-there he thought Lambert's suggestions were at first. "I was like, 'Flares? That's fucking crazy,'" the star recounts. Fast forward to Styles's solo career – an explosion of gowns, make-up and jumpsuits – and flares seem entry level. Styles credits Lambert with his recent dressing-up box approach to clothing. "He just has fun with clothing, and that's kind of where I've got it from," he told *Vogue*. "He doesn't take it too seriously, which means I don't take it too seriously."

Lambert hails from Norwich, the son of a policeman and a nurse. While he has said that his dad is quite a "flamboyant" dresser and that he himself won the prize for "best dressed" at his sixth form, it was interning at fashion magazines while studying that got him hooked on styling. By the time he was introduced to Styles, he was working as a stylist for Topman. Speaking about their first meeting, Lambert told *The Times* that

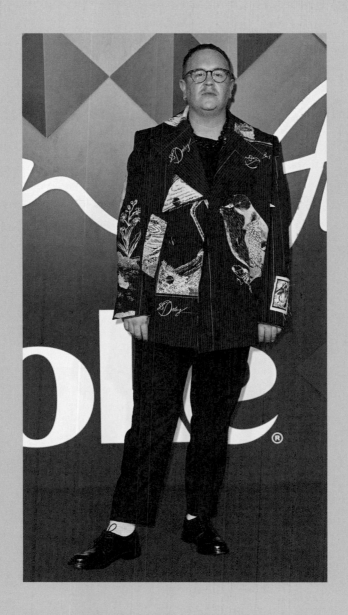

The other Harry – Lambert. Wearing an SS Daley jacket to the British Fashion Awards in 2022, the stylist brings flair to his own wardrobe too.

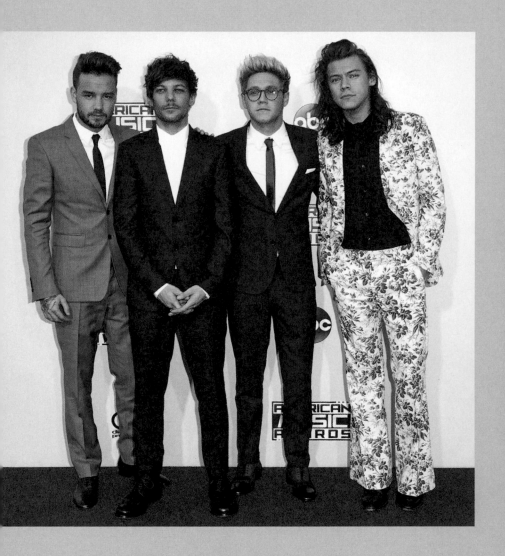

How to stand out from the crowd? Wear a suit that looks more like a sofa cover than something for the office.

OVERLEAF Styles experimented with his style while still part of One Direction. His striped flares and pussy-bow blouse present a marked contrast to his bandmates' T-shirts and jeans.

he brought along the labels that the pop star would go on to love – JW Anderson, Saint Laurent and Gucci. It worked because he read the room. "Harry has always been interested in fashion essentially ... You could kind of tell already from the way he was dressing and the decisions that he was making with brands."

Lambert is clear that theirs is a collaboration: it's not Styles as dress-up doll. This may be why the aesthetic cuts through so well. "I never want it to feel like he's wearing a costume, I never want to feel like something is wearing him," he's said. Lambert seems to embolden Styles – and he's been present behind the scenes for many key moments on Styles's journey to become a bona fide fashion icon.

Speaking to *Vogue* in 2019, Lambert identified a crucial moment on this journey: Styles wearing a floral Gucci suit with flares to the American Music Awards in 2015, while still part of 1D. It achieved the ultimate fashion goal of the modern era: it became a meme. Twitter compared the suit to everything from a bedspread to cushions. "[W]hy is Harry styles wearing my grandmas couch?" wrote one user. Beyond the viral moment, Lambert argues that this look was a statement of intent. "It was very exciting to see everyone's responses, but also how great he looked in it. At the time it was a very bold move to make." Men attending awards shows didn't wear outfits like this in 2015. Just look at Styles's bandmates in the photographs of the event, standing next to him on the red carpet in their simple grey and black tailoring.

This moment also signposted how influential Styles had become. When asked who made his suit, he told a reporter that it was Gucci – and the brand began to trend on Twitter worldwide. As Lambert told *The Face* in 2019, fans then began to wear similar suits in tribute to Styles.

"[Harry Lambert] just has fun with clothing, and that's kind of where I've got it from."

HARRY STYLES

The star, with Lambert's encouragement, has continued to make bold fashion moves. His Gucci look for the 2019 Met Gala was a close collaboration, one which involved Styles piercing his ear for the first time and wearing a see-through blouse. It was a shift from the seventies-style flares Styles had become known for – Lambert has described it as a step change. "It's time to try something new and hopefully shock and inspire in a different way," he told *Teen Vogue*. "I know the fans love his outfits, so hopefully they will love what's to come."

The fans have certainly bought into the look. Depop reported that searches for waistcoats and knitted vests were up 171 percent in 2022, a fact the app directly attributes to the two Harrys. Flares – those trousers that once seemed so shocking to Styles – are now one of the most searched-for items on the app.

As well as Styles, Lambert now dresses actors Emma Corrin, Eddie Redmayne and Josh O'Connor, and footballer Dominic Calvert-Lewin. It's clear, however, that Styles is the client whose stylistic choices actually shift modern standards of dress. The duo collaborate across everything – the red carpet, tours, videos and album covers – and they've made pearls, jumpsuits and nail varnish the new normal for young men everywhere. Speaking to the *Guardian* in 2022 about his legacy, Lambert said, "I just hope it's silly things such as putting Harry [Styles] in pearls and that men can wear necklaces and it not be a thing – that's the stuff I want to be remembered for ... It means that we've done something that has had cultural impact. It means we've got through."

The G-spot

Alessandro Michele, creative director at Gucci from 2015 to 2022, has had an undeniable influence on modern fashion, bringing a more genderfluid point of view onto the runway and into wardrobes. Under his stewardship, the brand grew more than 35 percent for five consecutive financial quarters and it made 9.7 billion euros in 2021. It could be argued, however, that this success wouldn't have been quite so stratospheric if it weren't for Michele's work with Harry Styles.

The two men first met in 2014 for a standard PR appointment between a celebrity and a fashion brand. Their relationship quickly became closer and they became firm friends, walking the Met Gala red carpet together in 2019. In 2020, Michele described Styles as "like a young Greek god with the attitude of James Dean and a little bit of Mick Jagger – but no one is sweeter. He is the image of a new era, of the way that a man can look." It's no wonder that, when Michele's exit from Gucci was announced in late 2022, the *New York Times* wrote "The departure of Alessandro Michele has big implications for the fashion industry. Also, what will Harry Styles and Jared Leto wear now?" (In Styles's case, judging by outfits at the Grammys in 2023, the answer is more Gucci.)

Prints charming ... Styles in Gucci for a *Love* magazine party in 2016. This was the beginning of his love affair with the brand.

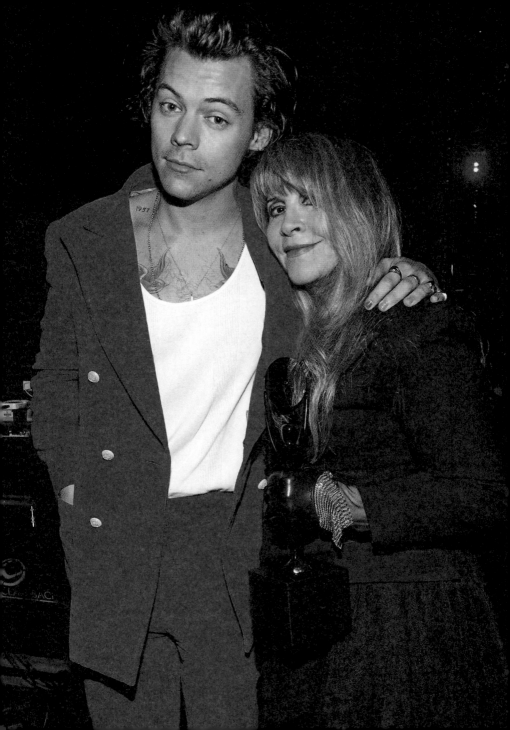

The partnership between the designer and the pop star saw Styles wear Gucci at parties (an early example was a checked suit worn to a *Love* magazine shindig in 2016) and off-duty (a Gucci hoodie in 2017; Gucci sneakers in 2022). But it's also seen Michele create pieces with Styles in mind – a harlequin suit worn on stage in 2017; items custom-made for the pop star to wear for his *Vogue* shoot in 2020. For red-carpet moments, Michele has come through, too – from the blue velvet suit Styles wore in 2019 to the sixties graphic number with matching handbag worn to the BRIT Awards in 2021. Styles has worn Michele for some of the high impact moments of his career including the cover of his second album, *Fine Line*.

The star clearly values the way that Michele works and he was in attendance at some of his Gucci shows. Speaking to *L'Officiel* in 2020, he said, "Alessandro is a free spirit and his way of working is very inspiring. If he wants to do something, he just does it, and I find that impressive, especially when you work for such a big brand." The influence is in what he wears, too. Asked by *Vogue* at the Met Gala who his style icon was, Styles smiled and pointed to Michele, who was wearing a pink puff-sleeved blouse and silver headdress. "This guy," he said.

A perfect pairing – in more ways than one. Styles with Stevie Nicks at the Rock and Roll Hall of Fame in 2019, wearing a blue velvet two piece by Gucci.

"*Alessandro [Michele] is a free spirit and his way of working is very inspiring.*"

HARRY STYLES

OPPOSITE The double G *and* a harlequin diamond? Styles shows off Gucci maximalism on stage in 2018.

OVERLEAF A very fashionable bromance – Styles with Alessandro Michele, both wearing Gucci finery, at the Met Gala in 2019.

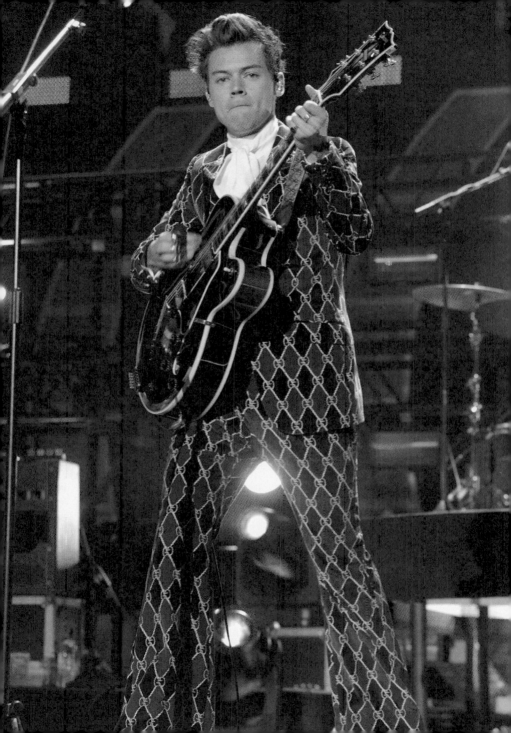

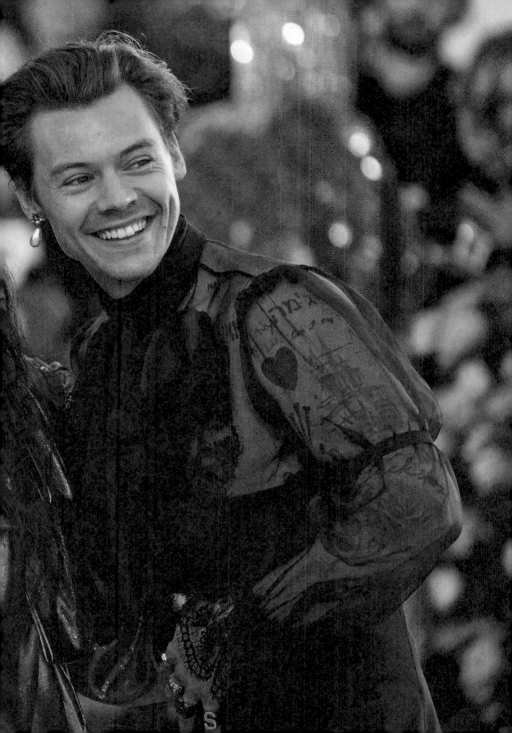

Considering this mutual appreciation society, it makes sense that Styles has appeared as the face of campaigns for Gucci under Michele. The pop star was in a series of adverts in 2018 – first photographed wearing Gucci in some very British locations, including a chip shop, and then melting hearts in photographs where he snuggles up to piglets and baby goats. Next up was an ad for a fragrance, Memoire D'une Odeur, which Styles quipped that he wears, Marilyn Monroe-style, to bed.

Pronouncements like these, and Styles's endorsement in general, helped Gucci's bottom line during the Michele era. Speaking to *Vogue*, the founder of @HSFashionArchive – an essential resource for all fans of Styles's style – said, "We have noticed that fans buy the Gucci pieces that Harry has worn. Though some pieces are pricey, we've seen people buy the loafers, boots, and bags that Harry has sported over the years."

The alliance was further developed just before Michele made his exit at Gucci in late 2022. Gucci Ha Ha Ha is a collaboration between Styles and Michele, a swan song for a memorable era and a fashion love story.

OPPOSITE Oink oink! A Gucci campaign featuring Styles and piglets redefined the concept of "cute" for fans in 2018.

OVERLEAF "Large chips, please." Another Gucci campaign of 2018 saw Styles take the brand to a location familiar to all Brits everywhere – the chip shop.

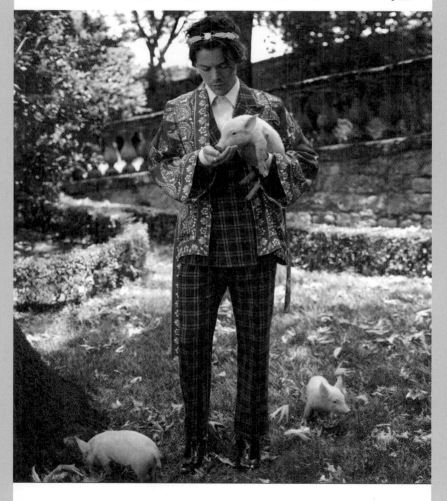

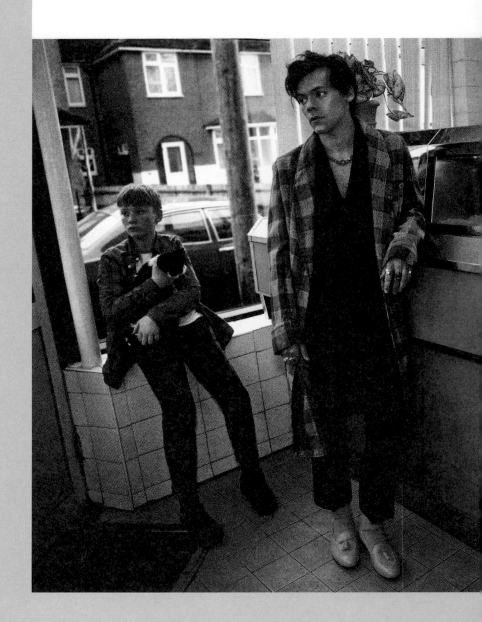

GUCCI

gucci.com

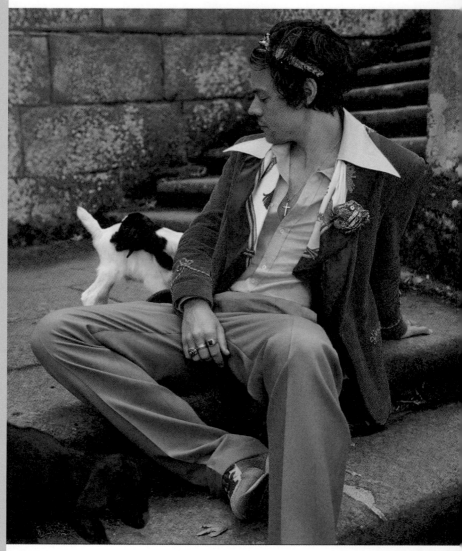

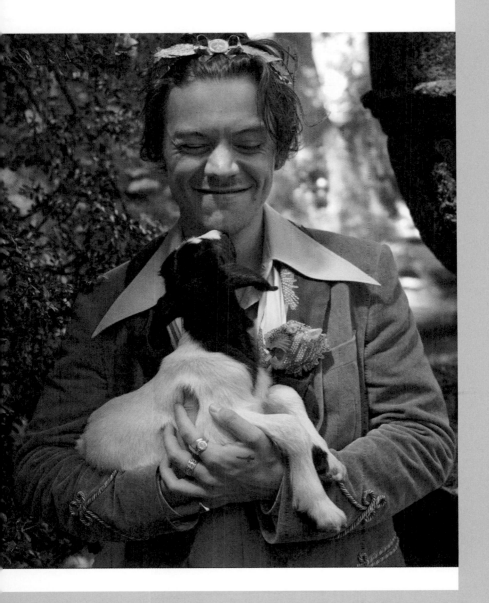

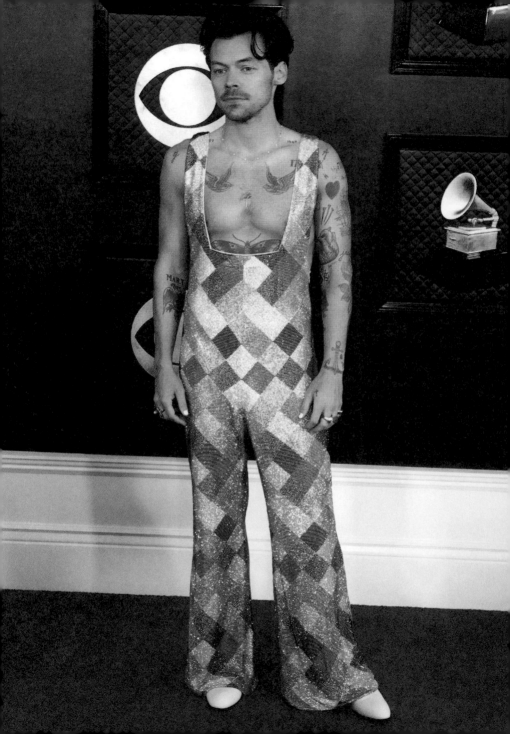

Designer goods

While many of the items in Harry Styles's tour wardrobe are labelled "Gucci", the star and his stylist Harry Lambert also look to emerging designers when it comes to great fashion. Styles often works with designers or brands long before they become household names. He'd cottoned onto the designs of Harris Reed before the designer graduated from London's Central Saint Martins in 2020: Styles wore a ruffled blouse and flares made by Reed in 2018. Palomo Spain – a Spanish genderfluid label launched in 2015 – was another early discovery, and Styles has worn pieces from the brand regularly over the years. See a cropped, double-breasted jacket on stage in 2018, a custom-made, frilled blue suit for the Variety Awards two years later, and a black and white monochrome jumpsuit onstage in 2022. Charles Jeffrey LOVERBOY is another favourite, providing Styles with directional takes on jumpsuits since 2018. Genderless label EGONlab is now in the fold – they made Styles's jumpsuit for the Grammys red carpet in 2023.

PREVIOUS Baby goats *and* Harry Styles wearing Gucci? Fans were in dreamland when they gazed on this 2018 campaign.

OPPOSITE Harlequin diamonds and tattoos: Styles on the red carpet for the Grammys in 2023 – wearing a jumpsuit made by EGONlab.

Speaking to *Vogue* in 2019, Lambert revealed something of the duo's process. "Every time a new season of shows happens, Harry and I will go through the shows and share looks we like, acting as a springboard for what he might wear." When they've created a mood board, the two Harrys then work out what look will suit an album or tour. The side effect of all this experimentation? A priceless boost for whichever brands they've picked. Being on the radar of the Harries (Styles's fans) can only mean good things for burgeoning careers.

SS Daley is a case in point. Styles wore Daley's designs in the video for "Golden" in 2020. The British designer, who launched his label the same year, won the prestigious LVMH Prize – and 3,000 euros – in 2022. Although of course Daley is a significant talent, the endorsement from Styles certainly helped. "The Harry Styles effect put our brand in a different lane," the designer told the *Evening Standard*. The "Harry" cardigan, featuring adorable knitted ducks, was worn by the star for the Spotify launch of *Harry's House* in 2022 and is now sold out. The alliance continues – Styles wore the label again at the BRITs in 2023.

Daley's designs found their way into Styles's videos via a very modern route – social media. After graduating from the University of Westminster mid-pandemic, Daley began selling some of his pieces on Instagram. "We had a global market with a few of our products almost instantly," he said. "Then Harry Lambert pulled stuff [borrowed designs for Styles to wear], and it sort of sparked a flame." Harris Reed was also an Instagram discovery for the duo.

Quack quack! Styles in a duck-adorned cardigan by SS Daley, worn for the launch of Harry's House in 2022.

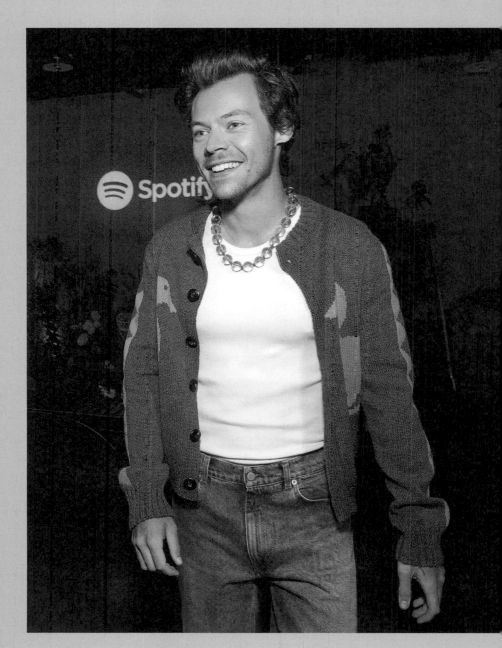

"Being on the radar of the *Harries* (Styles's fans) can only mean *good things for designers'* burgeoning careers."

A Charles Jeffrey jumpsuit – complete with a pinstripe – worn for *The Late Late Show* in 2019.

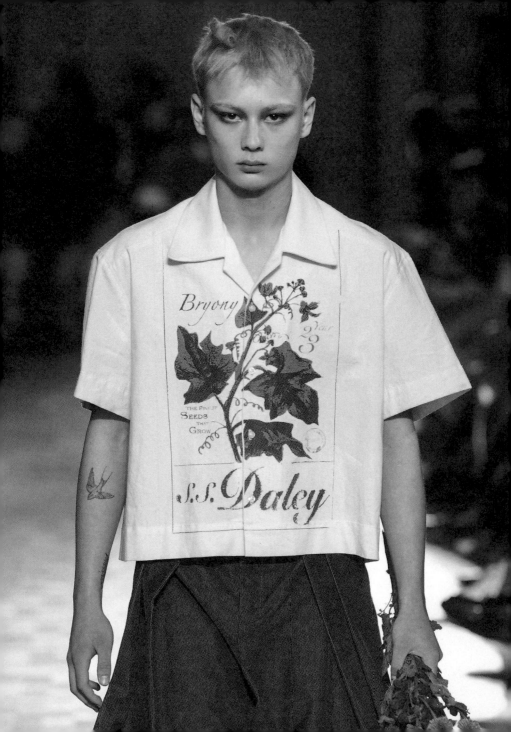

While designers JW Anderson and Molly Goddard were more established when Styles wore their creations, even their names have garnered a greater recognition factor due to the Styles effect. Goddard's custom-made pieces for the cover of *Harry's House* might have even eclipsed her previous moment in the spotlight, as the designer behind Villanelle's bright pink dress in the 2019 TV hit *Killing Eve*.

As well as boosting a designer's sales, the Styles effect can also make it possible for them to push the envelope on the global stage. Harris Reed is genderfluid and his designs reflect that. Put them on Styles – one of the biggest pop stars in the world – and their visibility and reach is increased. Reed and Styles starred together in a Gucci advertising campaign in 2019 and they have collaborated on everything from the crinoline-style skirt Styles wore in *Vogue* in 2020 to smoking jackets for his tour wardrobe, and a suit worn for the BRITs red carpet in 2023. "I'm fighting for beauty in fluidity and Harry just really understands the way gender can be restrictive," Reed told the *Observer* in 2021. It's still the *Vogue* look that dominates the headlines – something that Reed finds tricky to wrap his head around. "I wasn't surprised," he said, "but also ... how are we still outraged by a man in a dress in 2021?" Happily, it's moments like this – and collaborations like this – that allow us to ask these questions. And, perhaps, dilute that outrage one page view at a time.

Romantic, punk and wholesome too: a look from the SS Daley catwalk show for Spring/Summer 2023.

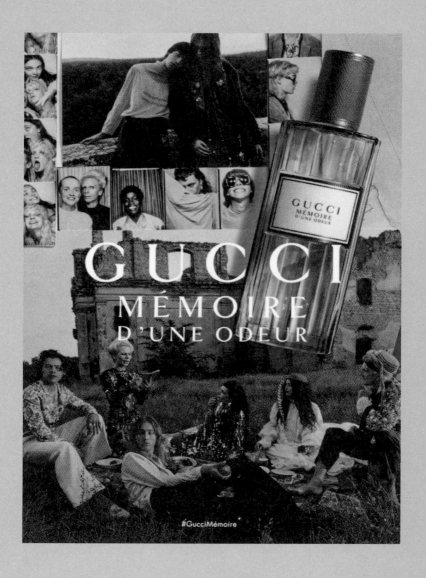

ABOVE Life's a picnic ... Harry Styles and Harris Reed (centre) having a ball, while starring in a Gucci advert together in 2019.

OPPOSITE Getting his flowers: Styles wearing a Nina Ricci suit designed by Harris Reed on the BRITs red carpet in 2023.

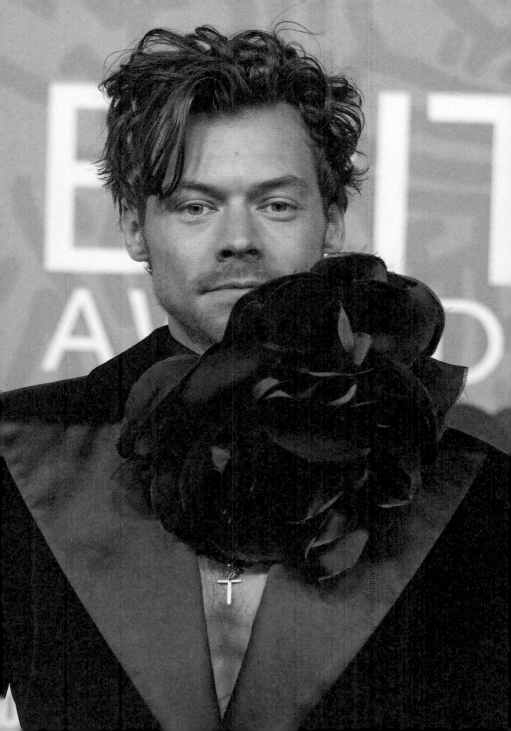

What makes you beautiful

Whether as a creator of clothes or music, Styles is all about doing things in the nicest possible way. In 2019, Styles's song "Treat People With Kindness" was released as part of *Fine Line*, its video featuring *Fleabag* creator Phoebe Waller-Bridge wearing an outfit that matched Styles's. He took the message further the following year when the slogan appeared on T-shirts and hoodies as part of his merch, some in the rainbow colours of the Pride flag. Styles modelled the range in public appearances, wearing a TPWK pin on his yellow Marc Jacobs suit at the BRIT Awards in 2020. The slogans have changed, but his merch remains in high demand, with fans camping outside venues in Manchester to get their hands on it in summer 2022.

Styles has gone beyond the usual tour T-shirts, too. In 2021, he launched Pleasing, a collaboration with Harry Lambert and Styles's creative director Molly Hawkins. *Dazed & Confused* Magazine described the venture as a "shape-shifting umbrella

LEFT Wear your heart on your lapel
– the Treat People With Kindness
pin worn to the BRIT Awards.

RIGHT Mellow yellow: Styles wears a Marc
Jacobs runway look at the BRIT Awards in 2020.

OVERLEAF Styles' slogan gets everywhere
– including an autographed guitar
sold in a charity auction in 2020.

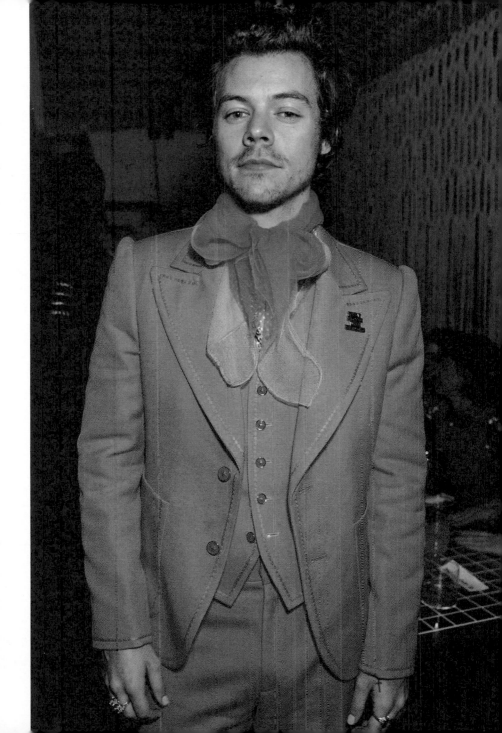

company that will see him take the leap from musician to mogul."

Pleasing began with nail varnish – something of a Styles staple – but has expanded to include clothing and skincare. There's even been a collaboration with Brazilian designer Marco Ribeiro on a range of make-up. For each collection, the brand partners with a different charity – including Queercircle, who work with the arts and the LGBTQI+ community, and climate activists Cool Earth. Appropriately for a Styles project, the Pleasing website states that these initiatives are a way to "celebrate the kindness, creativity and optimism in our community and the future we are all creating together."

Interestingly, Styles himself is not the frontman of Pleasing. Instead, he's let Lambert and Hawkins take the reins in the development of different products and the launching of pop-ups everywhere from London to LA over the winter of 2022. If this slight distance between pop star and product represents a contrast with other celebrity beauty lines, it seems that even the faintest whiff of Styles's involvement keeps Pleasing in the hearts of fans. In November 2022, *The Business of Fashion* published an article entitled, "Why Harry Styles Fans Can't Get Enough of Pleasing" in which journalist Rachel Strugatz interviewed some visitors to the New York store. 19-year-old Grace Daniels said she found Styles's hands-off approach more genuine: "He [Styles] wants this to be [its] own separate entity rather than something that's solely related to him. At the same

Hi! Styles's hand waving to fans, wearing what is no doubt Pleasing nail varnish – plus some extremely impressive rings – in 2022.

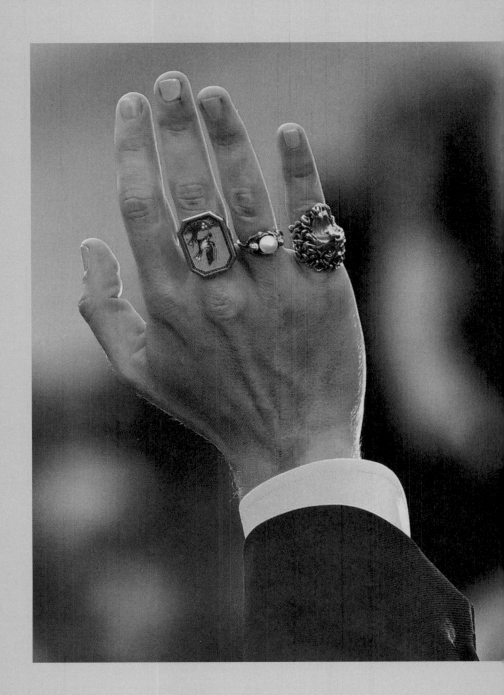

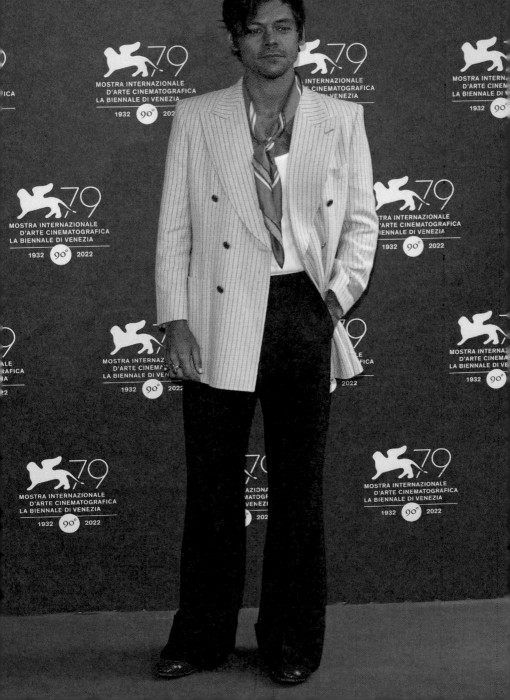

time, it is very Harry – it's very eccentric." 20-year-old Alyssa Coy had hearts for eyes when it came to Styles. When interviewed, she compared him to an adorable ceramic duck on display in-store.

It wasn't a duck but a bear that was emblazoned on the first item issued from Styles's most anticipated design collab yet – with Gucci and its outgoing creative director Alessandro Michele. Launched in November 2022 and entitled Ha Ha Ha (in honour of the duo's initials and the way they sign off their messages to each other), the creative partnership was described by Michele as "a true act of love".

Styles offered fans a preview of the aesthetic on tour in the summer of 2022. See a seventies-style ringer vest adorned with a teddy bear and Styles's lyric "I want more berries and that summer feeling", worn for a gig in LA. It was as sweet and eccentric as any fan could desire. Styles followed up this look with a *Talented Mr Ripley*-style louche Ha Ha Ha suit, accessorized with a neckerchief, and a blue suit, both for the Venice Film Festival.

When it landed, the Ha Ha Ha ad campaign featured Styles in pastel suiting, Styles in a checked skirt, Styles in pyjamas, Styles wrapped up all sleepy in a gingham suit and Styles in his pants – an image that no doubt made all self-respecting Harries swoon. The prices of the pieces, however – £500 for a T-shirt; £1450 for a sweatshirt – probably prompted a different reaction: shock.

A jaunty look ... Styles wears designs from
Gucci Ha Ha Ha at the Venice Film Festival in 2022.

"The Gucci Ha Ha Ha collection was as *sweet* and *eccentric* as any fan could desire."

OPPOSITE Styles wearing all kinds of blue – and a suit from his Gucci Ha Ha Ha collection – at the Venice Film Festival in 2022.

OVERLEAF All wrapped up ... Styles is snug as a bug in a rug, wearing a gingham suit in the campaign for Gucci Ha Ha Ha.

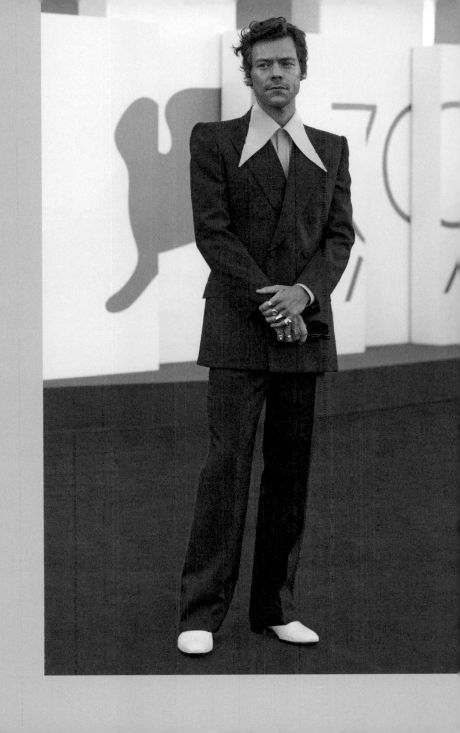

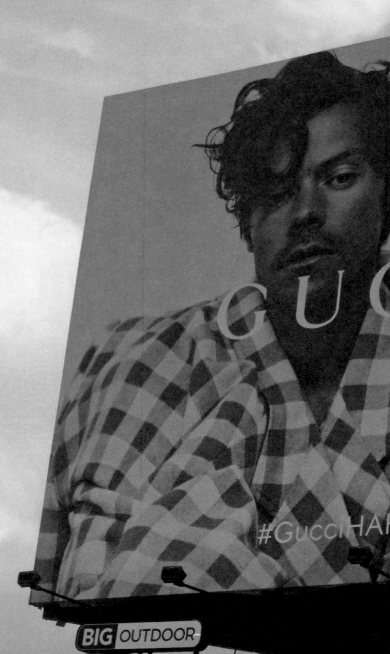

GUCC

#GucciHA

Closeknit

In February 2020, Harry Styles was photographed rehearsing for a performance on the *Today* Show wearing a JW Anderson cardigan made of assorted patches of brightly coloured knits, a slogan T-shirt and pearls. For Styles, it was a low-key outfit but to the internet it was everything.

Styles's cardigan had been priced at £1250 – a lot more than most of his fans would usually pay for knitwear. Instead, in the early stages of the pandemic, against a backdrop of "stay at home" culture as lockdowns unfolded across the world, they decided to make the piece. The hashtag #harrystylescardigan began to trend on TikTok, leading to a plethora of videos showing how different creators made their versions of the knit. Liv Huffman, a craft-loving twenty-something with over 820,000 followers, played an instrumental role in the cardigan's viral moment. She posted a video on 15 June and by July, it had three million views and nearly a million likes, by which time there were already 330,000 videos with the hashtag on TikTok. At the time of writing, Huffman's original video has 101 million likes. Others, including vintage dealer and influencer Pernille Rosenkilde have also been spotted wearing their version.

The start of a viral moment ... Styles in his JW Anderson cardigan, at the *Today* Show in 2020.

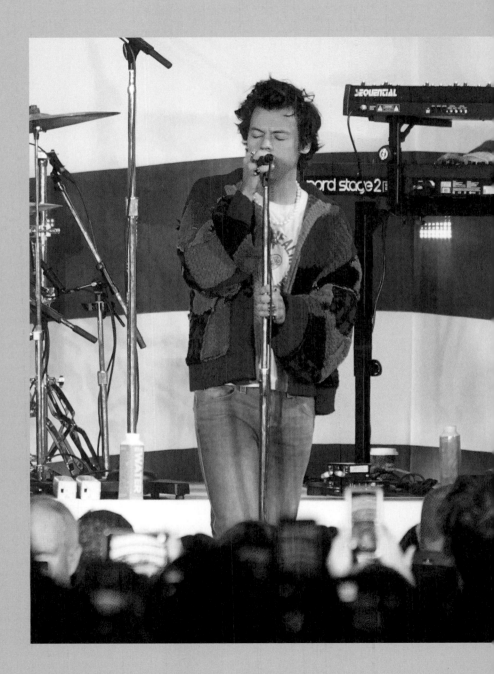

Harry Lambert is owed partial credit for the cardigan's moment. The stylist found the piece on sale on matchesfashion.com. He encouraged Styles to wear it not for the show but for rehearsal snaps and video interviews before it because he had noticed that pre-show moments had even more reach. "I remember him saying, 'OK, I love it, I just don't know why we're wearing it for rehearsals,'" Lambert told *The Times* in 2021. "I was like, 'Wear it for rehearsal – I promise you.'"

Lambert's instincts were right, of course. The cardigan was a massive hit, sparking a huge upswing in searches for the item online. Then JW Anderson did something unexpected and exactly right for the audience and the moment. He shared the pattern for the cardigan to allow all wannabe knitters to make their own. In a statement, the designer said, "I am so impressed and incredibly humbled by this trend and everyone knitting the cardigan ... Keep it up!"

The cardigan is so famous it's in a museum. In November 2020, London's V&A acquired the piece, now noteworthy for three reasons – the way it represented a pop star's style, Anderson's innovative approach to fashion and our creative resilience at the toughest of times. Writing about the acquisition on the V&A website, curator Oriole Cullen said it spoke "to the power of creativity and social media in bringing people together in times of extreme adversity even when we are locked down in our own homes." Appropriately, Anderson's design was displayed alongside Huffman's version of the piece.

Pernille Rosenkilde wearing a version of Styles' knit made by her mum at Copenhagen Fashion Week in 2022.

"*I am so impressed and **incredibly humbled** by this trend and everyone* **knitting the cardigan ...** *Keep it up!*"

JW ANDERSON

The knit before the storm: the original cardigan, as seen on the catwalk for JW Anderson's show in 2019.

Performance

CHAPTER 4

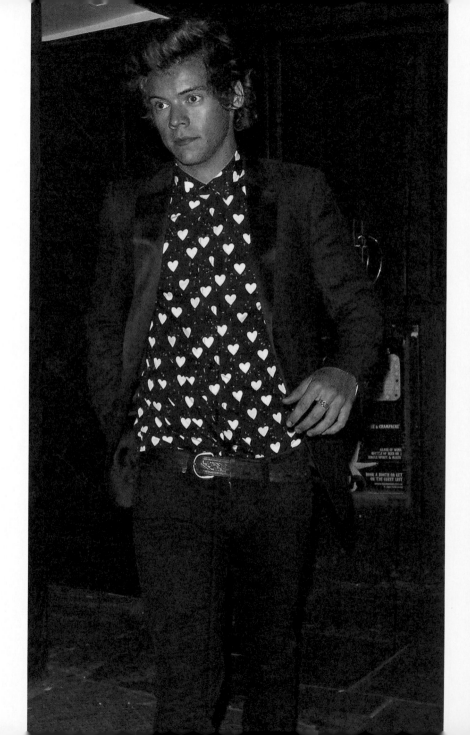

Suits you

The release of Harry Styles's debut solo album in 2017 was much anticipated on social media. Styles caused a ripple among his fanbase when he posted its cover, which featured his naked back in the bath. The internet reached fever pitch in the days leading up to the release, when a leak revealed an image from the album's artwork. In the picture, Styles looks every inch the romantic idol in a blouse and a blue velvet suit made by womenswear brand Hillier Bartley. "Both outfits," reported *Teen Vogue* breathlessly, "are further proof that Harry can truly pull off every look with confidence."

Styles first came to our attention as an indie-adjacent teenager in slubby knitwear and baggy trousers but, in something of a style plot twist, it's tailoring that's turned out to be his calling card. He loved a blazer while still in One Direction, and often combined it with a jazzy shirt, as for the premiere of band documentary *This Is Us* in 2013. By the time he began working with stylist Harry Lambert and Gucci designer Alessandro Michele a couple of years later, tailoring was his way of standing out from the crowd – the crowd being his fellow band members. See, for example, that striking floral Gucci suit worn at the American Music Awards in 2015.

An early take on tailoring – Styles wears a black blazer and printed shirt for the premiere of *This Is Us* in 2013.

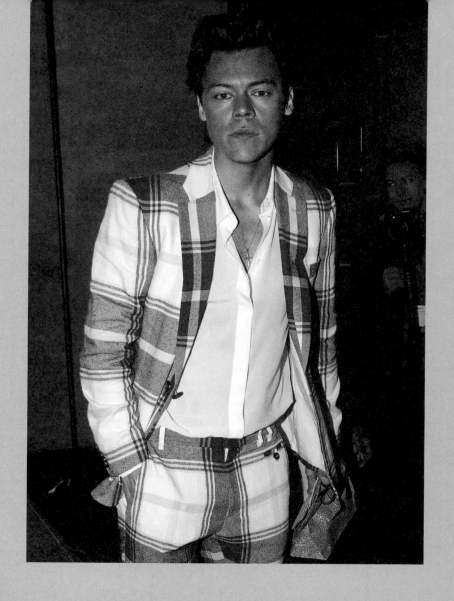

ABOVE Check, mate ... Styles wears a typical statement suit
(made by Vivienne Westwood) for a BBC appearance in 2017.

OPPOSITE A symphony in aqua – Styles plays with colour
in suiting, on stage for a Victoria's Secret concert.

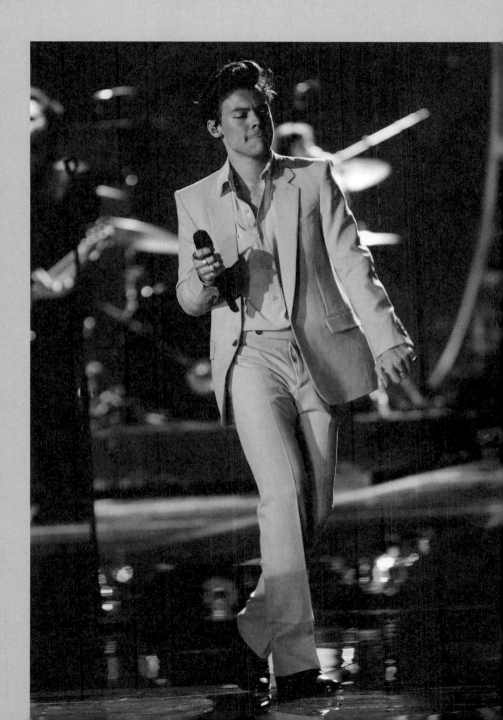

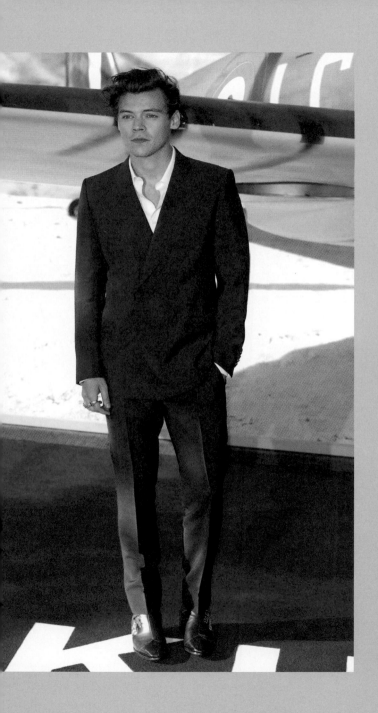

With his debut solo album came a tour, and this is where Styles's love of a fabulous suit came into its own. These weren't the kind of suits found on Savile Row or worn by ushers at weddings. If the suit is an established element of the traditional male wardrobe – there since the eighteenth century, no less – Styles loves nothing more than subtly subverting this kind of code. His suits are not about blending in. Instead, they are loud, printed and a whole lot of fun. From 2017 alone, we can admire a selection that includes a red and white checked number, floral suits in red and in blue, sometimes worn with soft chiffon blouses, suits that play with colour (a pink one, for a *Today* Show performance) and print (a harlequin pattern). There was even the occasional more understated design – such as the grey double-breasted suit worn for the premiere of *Dunkirk*.

Styles knew he was onto a winner with this formula. He continued to play with floral suiting into 2018 and 2019. In 2018, he wore a memorable design featuring mega-flares for his first performance at Madison Square Garden, while a blue lurex suit worn over a pussy-bow blouse for a concert in Copenhagen felt like an update on sixties lounge singer style.

OPPOSITE Styles's suits aren't always bold and bright. Some – like this one worn for the premiere of *Dunkirk* in 2017 – are sleek and sophisticated.

OVERLEAF A gig means a Gucci suit. This one – a cheery floral – offers a dramatic contrast with a black silk blouse.

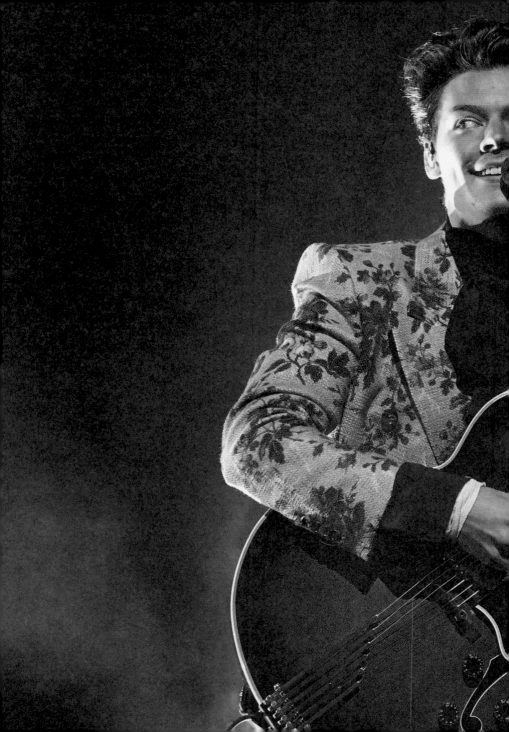

"*If the suit is an established element of the traditional male wardrobe, Styles loves* nothing more than *subtly* subverting *this kind of code.*"

A romantic take on the suit ... in red brocade with black flowers, this Gucci design came out for a gig at Radio City Music Hall in 2017.

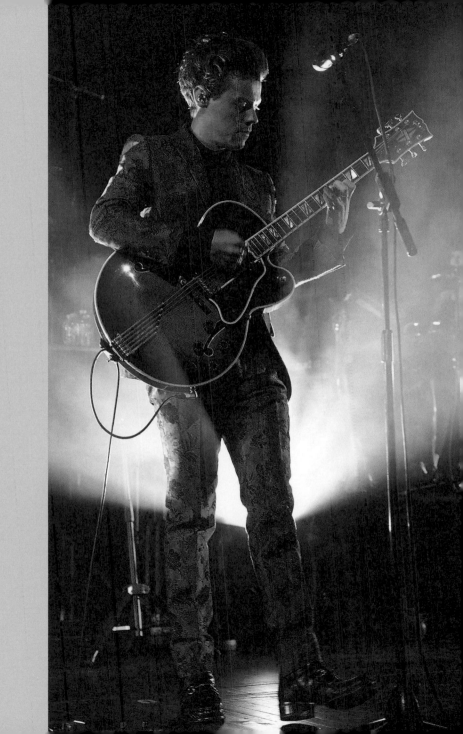

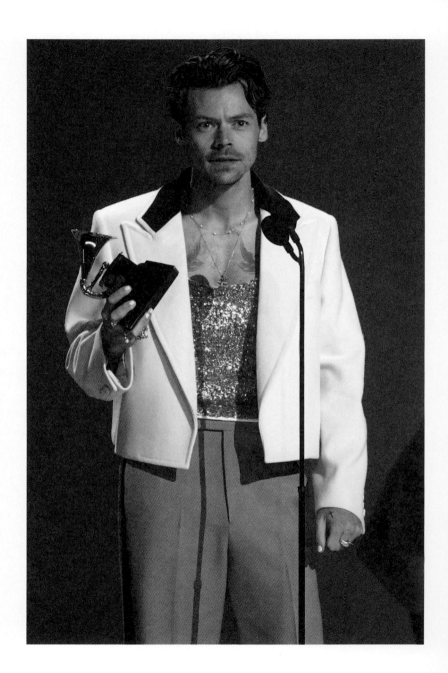

There's always an end to a formula when a signature becomes predictable. Styles has sidestepped this pitfall by mixing it up. These days, he often wears jacket and trousers in different colours or in different shades of the same colour. See a bottle green jacket and pea-coloured trousers for the Toronto Film Festival in 2022, and his Grammy acceptance outfit in 2023. The effect is more casual and a bit surprising.

Another option is amping up formal. For the premiere of *My Policeman* in 2022, Styles was understated – almost minimal – in a black suit with a high collar, worn with a shiny black belt. Inevitably, it caused a bit of stir, with a *GQ* headline about the look reading "Who are you, and what've you done with Harry Styles?" in response to the lack of Styles's trademark colour and frills.

Styles's love of tailoring in all its guises has influenced the designs he's been involved in, too. In his 2022 collaboration with Gucci designer Alessandro Michele, Ha Ha Ha, suits feature heavily, from a checked three-piece to a more relaxed denim design. Michele described the collection as "a mix of aesthetics from seventies pop and bohemia to the revision of the image of the gentleman in an overturned memory of men's tailoring". Sounds suitably subversive.

OPPOSITE Styles accepts his Grammy for Album of the Year in 2023, wearing a now-familiar take on mixed-up tailoring – and a glitzy top for good measure.

OVERLEAF For Madison Square Garden in 2018, Styles had a "go big or go home" approach to clothing – his Gucci suit featured mega-flares.

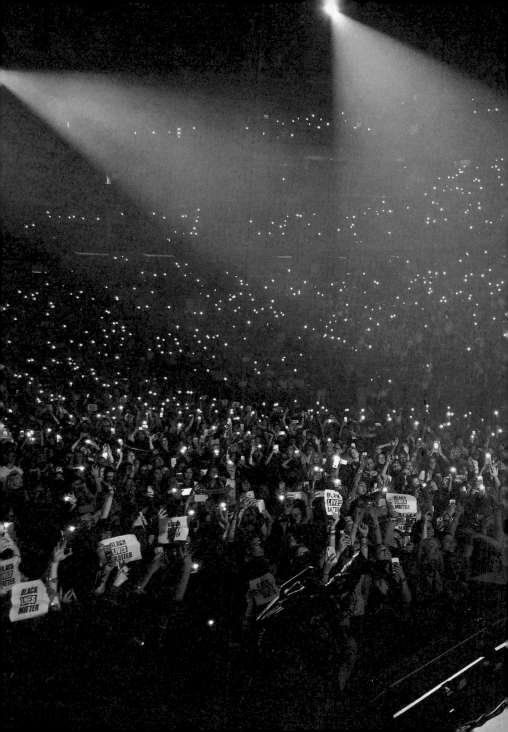

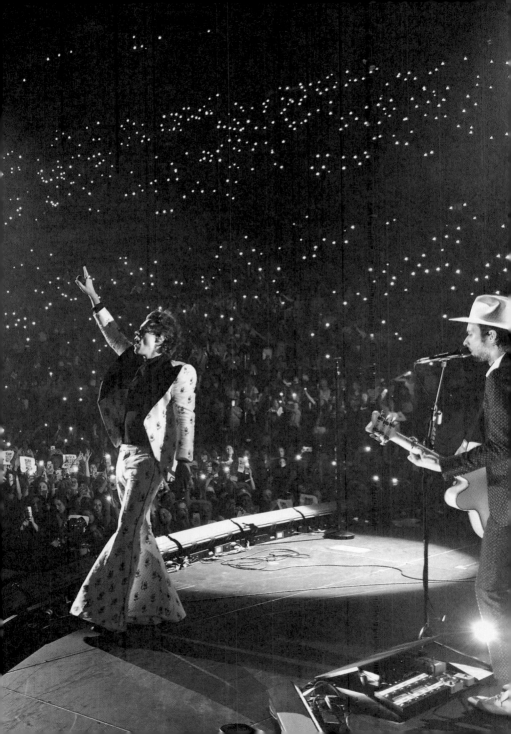

ABOVE Keeping it simple – this minimal black suit with a shiny belt was so unlike Styles's usual attire that it caused something of a stir.

OPPOSITE A green light ... Styles loves to play with different shades of a single colour, as in this outfit worn at the Toronto International Film Festival in 2022.

Dress you up in my love

Harry Styles's predilection for dressing up began early. Gemma Styles, his sister, remembers their mother dressing the siblings in all sorts of outfits when they were children – including a papier-mâché World Cup costume and a Dalmatian dog suit that had been given to them by family friends. "He would just spend an inordinate amount of time wearing that outfit," she told *Vogue*. "But then Mum dressed me up as Cruella de Vil. She was always looking for any opportunity!"

While Gemma wasn't a fan of the costumes, Styles loved them. His enthusiasm has stood him in good stead in his adult career as one of the most dressed-up pop stars of the modern era. Styles's take on fashion is still imbued with that sense of freedom and imagination he possessed as a young child – a capacity for the dramatic that allows him to embody a more capital-H version of himself. "I think if you get something that you feel amazing in, it's like a superhero outfit," he said to *Vogue*. "Clothes are there to have fun with and experiment with and play with."

Styles lives by this rule of thumb and encourages others to do the same. His sensibility is a perfect match for Halloween, a holiday for which dressing up isn't an add-on but a requirement. Styles embraces this. In 2018, he went to a party in LA dressed as one of his heroes, Elton John, wearing a crystal-covered strip for the LA Dodgers,

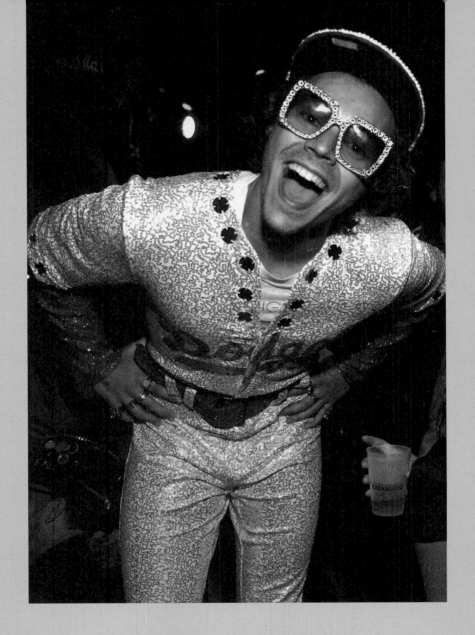

The Rocket Man as you've never seen him before ...
Styles as Elton John for Halloween in 2018.

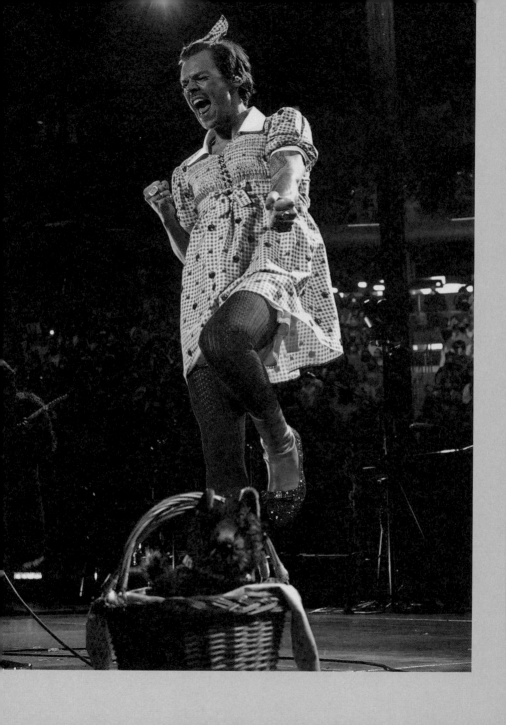

as John had worn for a famous performance in the city in 1975. Combined with square Gucci glasses, a baseball cap and a John-like stance, the resemblance was undeniable. So much so that John took to Instagram, posting a picture of Styles with the caption "now that's what I call a Halloween costume". GQ was full of praise too, with an article entitled "It's over, we're done, Harry Styles has won Halloween".

In the years since, Styles has continued to win at this holiday – so much so that in some parts of the internet during autumn 2021, Halloween ceased to be and in its place came Harryween. For two sold-out shows at Madison Square Garden in New York (delayed from the previous year due to the pandemic), Styles presided over a costume party like no other. For 30 October, he wore a short gingham frock, rosy cheeks and ruby slippers in stylistic tribute to Dorothy in *The Wizard of Oz*, complete with basket and Toto the dog (his band also went to Oz, with guitarist Mitch Rowland particularly fetching as The Cowardly Lion). And for actual Harryween? Styles went to town in a Pierrot clown costume boasting mega frills and pointy heels. The ensemble might have been an homage to his hero David Bowie, who wore a Pierrot outfit in the video to *Ashes to Ashes* in 1980, or maybe it was just because, for Styles, fashion is about fun and the more fantastical the better. "I must say, I feel fabulous," he said to the crowd during the first gig. "Do you feel fabulous? Good!"

There's no place like home ... Styles in his element, dressed as Dorothy from *The Wizard of Oz*, for Harryween in 2021.

For Styles, this was a crucial question – because he sees a concert as an experience shared collectively between him and his many, many fans. He dressed up, so they dressed up too. In New York, the Harries wore everything from a version of that Elton John costume to feather boas, cowboy hats and angel wings, Bowie suits and cheerleader outfits. One, photographed by *Vogue*, carried a sign that read "my therapist says this is good for me". With so much sheer joy in the room, you can understand why.

Styles brought the excitement back again a year later. By the autumn of 2022, Harryween had become a regular thing. At the time of writing, there are more than 57,000 posts on Instagram bearing the hashtag #harryween and videos with the hashtag have been viewed nearly 580 million times on TikTok.

Clowning around … Styles in a Pierrot suit worthy of his hero David Bowie for Harryween in 2021.

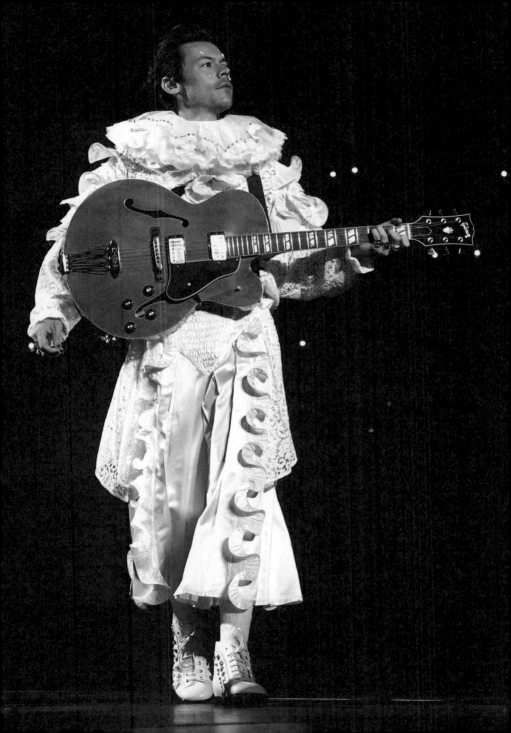

"*I must say, I feel fabulous. Do you feel fabulous? Good!*"

HARRY STYLES TO THE CROWD AT MADISON SQUARE GARDEN, 2021

OPPOSITE If Styles dresses up, so do his fans. See this outfit worn for one of the Love on Tour gigs in 2022.

OVERLEAF Fans gather outside before a Styles gig in 2022. Dressed-up outfits and huge grins come as standard.

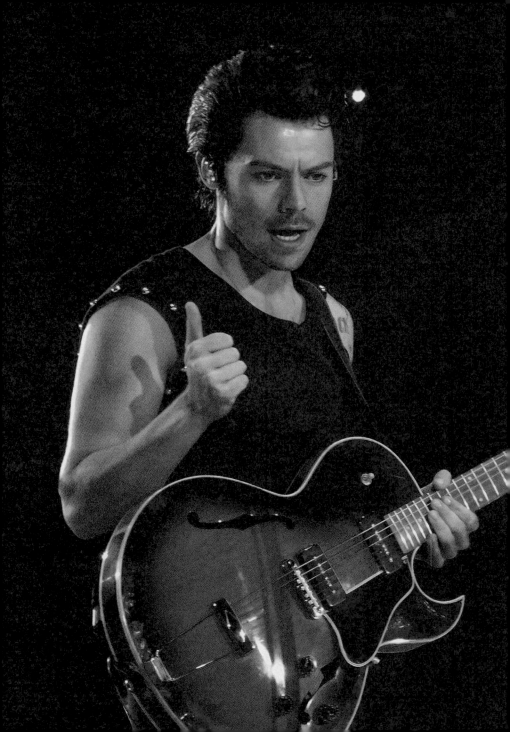

Always one to have a razor-sharp vision of what works for right now, Styles dressed for the 2022 LA Harryween in homage to another movie character: Danny Zuko, from enduringly popular 1978 film *Grease*, complete with black quiff, biker jacket and cut-off T-shirt with "Harryween" spelt out in red crystals on the back. The concert took place a few months after the film's other lead, Olivia Newton-John – who played Sandy Olsson – had died of cancer. It was a timely reference and Styles even sang Newton-John's wonderfully weepy ballad from the film, "Hopelessly Devoted to You". The band came dressed as the students of *Grease*'s fictional Rydell High – drummer Sarah Jones did her best Sandy impression.

Styles effectively paid tribute to a star while giving the Harries the levity expected from a Harryween. "This wig is very warm, so if at any point during the show I fall to the ground, don't be alarmed," he joked, early in the evening. For someone who's been dressing up for the best part of a decade, these little challenges aren't really a trial. In fact, they're all part of the fun.

Greased lightnin' ... Styles does his take on *Grease*'s Danny Zuko for Harryween 2022.

Got the look

In 2023, there are very few major musical artists who rely solely on music for their success. Visuals – videos, album covers, tour costumes, red-carpet looks and off-duty outfits – are essential when you're trying to climb up the charts. Harry Styles provides something of a blueprint as to how to make this work – he's someone for whom sound and visuals have been two sides of the same coin, ever since he went solo in 2017.

His album covers have been a key element of this visual journey, and they are a collaborative effort, shaped by Styles and the team around him. Speaking to the *Guardian* in 2019, he explained, "In terms of how I wanna dress, and what the album sleeve's gonna be, I tend to make decisions in terms of collaborators I want to work with. I want things to look a certain way."

The star set out his stall with his eponymous first album, the one that featured his naked back in the bath, photographed by Harley Weir, a young photographer known for her intimate portraits and work for *Dazed & Confused* and *Vogue Italia*. Its release prompted the spread of intrigued interpretations across the internet. *Billboard* analyzed the image like an art critic considering a painting in a gallery. "Given the bath-like qualities of the image and his positioning away from the viewer," wrote journalist Maria Sherman "it feels more voyeuristic – and in some ways, melancholic." Deep.

"*I tend to make decisions in terms of* collaborators *I want to work with. I want things to* look a *certain way.*"

HARRY STYLES

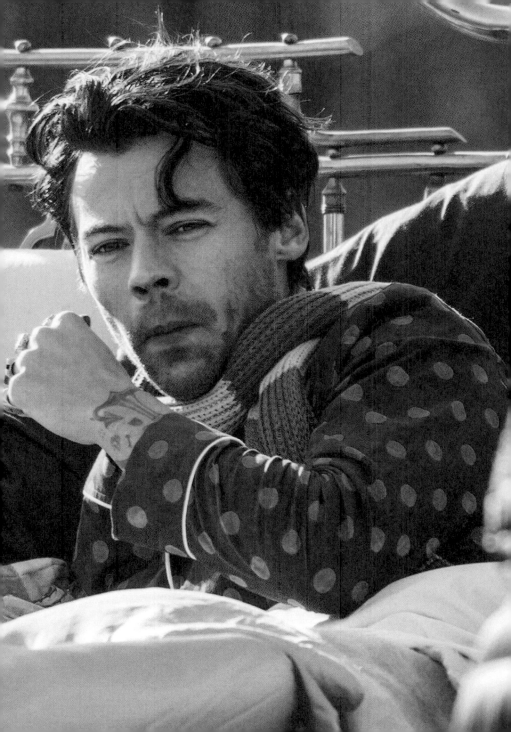

Fine Line, two years later, had a different feel. Styles was photographed by fashion's favourite fantasist, Tim Walker, using a fisheye lens. The image recalled sixties pictures of the Jimi Hendrix Experience and also Hype Williams videos from the nineties. Styles wore a pair of white sailor trousers and a pink satin blouse, with a gloved hand beckoning to him in the foreground. *The Ringer*, in an article which asked 29 breathless questions about the album cover, queried "Is this a sex thing? (It's OK if it is a sex thing; I just want to know going in that that's the intended vibe.)"

2022's *Harry's House*, meanwhile, was photographed by Hanna Moon, who has worked for brands like Gucci and magazines including *AnOther*. This cover was even more surreal, depicting Styles in a room that appears to have furniture on the ceiling. No wonder he looks a bit quizzical standing there in his custom-made Molly Goddard blouse and jeans.

Music videos are as much part of Styles's schtick as modelling for cover art and they're often cinematic in their ambition. The video for "As It Was" became YouTube's third most viewed of 2022. Other popular videos include "Adore You", set in a rather strange Cornish fishing village, "Watermelon Sugar", making the most of a sunny beachside setting and "Golden", which once again sees Styles by the seaside, at one point jumping into the ocean. Since that first solo album, water has been a theme of his visual identity – see also "Falling", which features a piano overflowing with water. Asked about the water theme in 2020, he said it symbolised birth and purity, adding "there's nothing that makes you feel more human than the ocean".

Styles knows that as an entertainer, his job is to help the viewer travel somewhere else while they're watching a pop video. He was spotted filming one dressed as a bird in 2022, while some of his most popular videos were released during the pandemic and seem to comment on the moment, and our collective desire to escape it. "Watermelon Sugar", released in May 2020, is prefaced with the statement "this video is dedicated to touching" while "Golden", released in October 2020, is designed to boost a viewer's mood. "I'd like to think it will maybe cheer a couple of people up. Cheered me up," he said to *Associated Press*.

Videos to make the viewers smile kept on coming with the release of *Harry's House*, and the watery theme has remained a constant. "Late Night Talking" saw Styles in his jammies, taking part in an actual pillow fight, while "Music for a Sushi Restaurant" casts him as a merman, complete with fishy tail. Predictably, it was loved by fans. "If you had told me that I would [be] watching harry styles as a singing half squid, I would have maybe believed you. but still. that was something! [sic]", wrote one admirer on Twitter. It certainly was.

OVERLEAF Flying like a bird – Styles in yellow and black feathers (and also some smart brogues) while filming a music video in 2022.

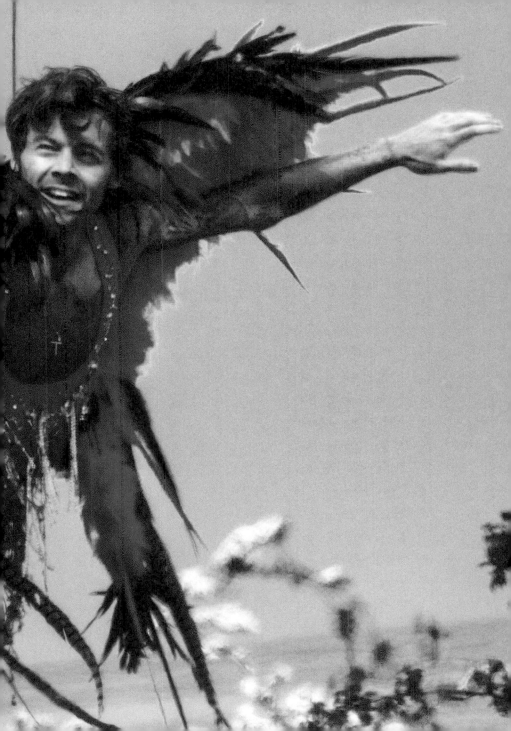

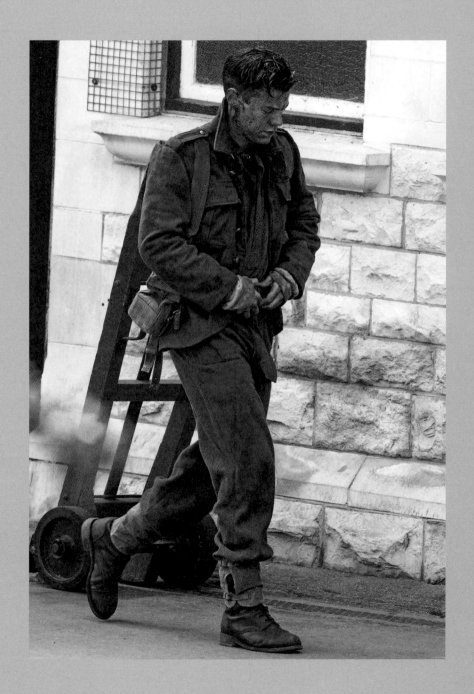

The camera loves you

In 2016, Harry Styles was a busy man. He was working on his much-anticipated debut solo album and starting out in a whole new career: acting. Following childhood star turns in school plays, Styles's film debut wasn't some bit part in a low-budget short. He played a soldier, Alex, in *Dunkirk* – the Second World War epic made by acclaimed director Christopher Nolan. The role saw him actually jump in at the deep end, with one of his main scenes requiring filming in the water for an hour. "It was hard, man, physically really tough, but I love acting," he told *Rolling Stone*. "I love playing someone else. I'd sleep really well at night, then get up and continue drowning."

Styles's take on fashion and style is all about imagination and the transformative power of clothes. So dressing up as someone else – in a literal costume – isn't a stretch. After the release of *Fine Line* in 2019, he came back to acting, taking on three film roles in quick succession from October 2021 (using time meant for touring after live events were paused due to the pandemic). The first was in Chloé Zhao's superhero film, *Eternals* – a blink-and you'll-miss-it moment in the end credits. He plays Eros or Starfox, the brother of ultra-strong character Thanos, in a suitably Marvel outfit of red cape, gold chest plate and red tights.

Looking the part ... Styles decked out in an army uniform, and some mud, while filming *Dunkirk* in 2016.

In 2022, Styles starred in two films – *Don't Worry Darling* and *My Policeman*. Both were set in the fifties. Styles played an alcoholic with a mysterious job in the first and a married policeman who's secretly in a gay relationship in the latter. *Don't Worry Darling* director Olivia Wilde saw Styles's fashion sense as a boost for her film. "It's very heightened and opulent," she said, about the film's style, "and I'm really grateful that he is so enthusiastic about that element of the process – some actors just don't care."

Styles most certainly cares. All his film roles so far have featured costume at their heart, whether it's the uniform of a World War Two soldier or that of a policeman, suits worthy of *Mad Men's* Don Draper or a superhero outfit complete with cape. Perhaps these clothes are part of how he channels a character. Explaining his process to *Dazed & Confused* in 2021, he said, "you're trying to remove a lot of yourself and key into someone else. On the most basic level, it's like being a kid and you're playing pretend."

OPPOSITE An officer and a gentleman ... Styles dons another uniform while filming *My Policeman* in 2021.

OVERLEAF Styles put his love of suits to good use in 2022's *Don't Worry Darling*. Set in the fifties, the film saw him cast opposite highly regarded actor Florence Pugh.

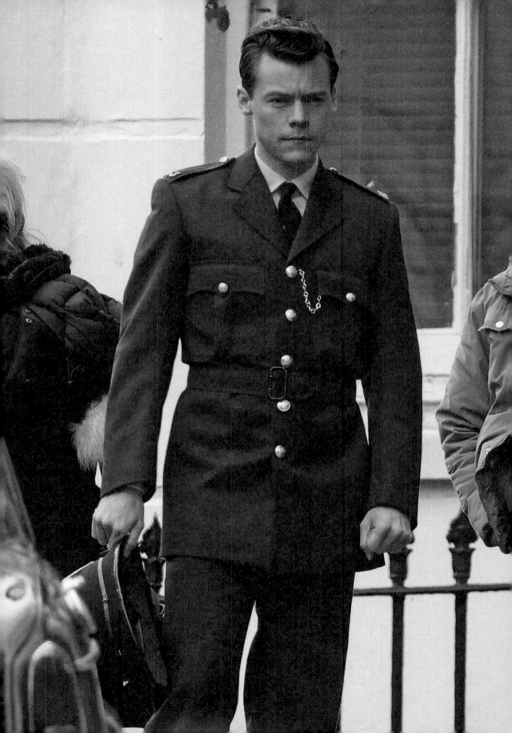

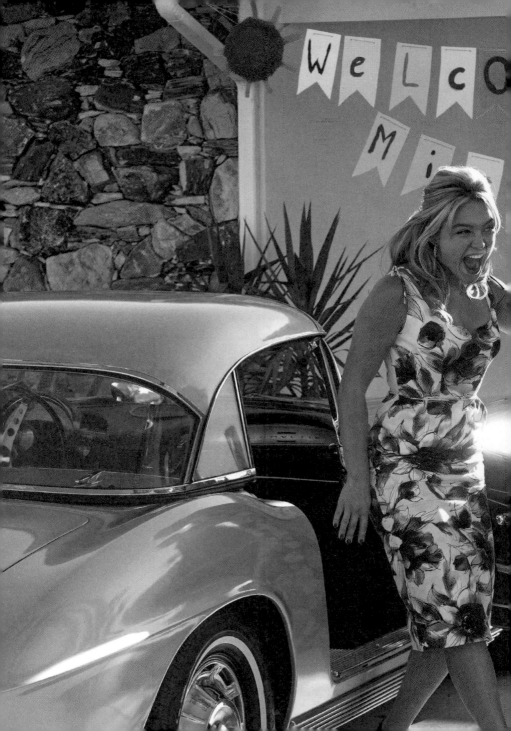

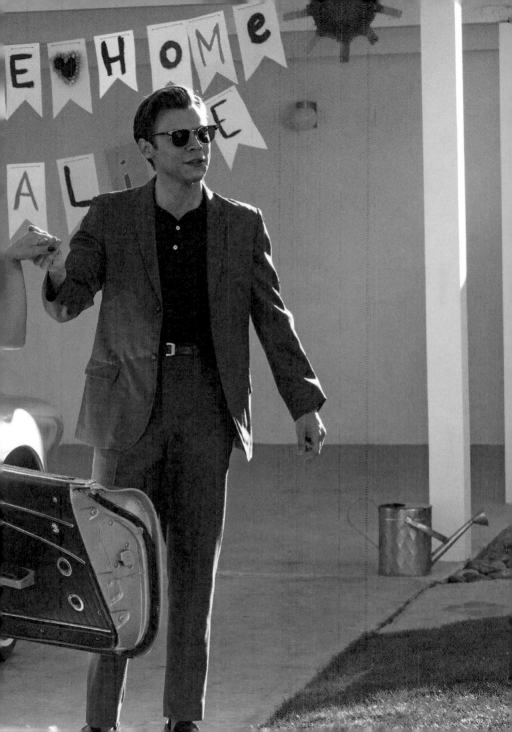

Styles's acting hasn't always garnered rave reviews – the *Independent* described his turn in *Don't Worry Darling* as "charisma free" (ouch). But he definitely excels at the red-carpet appearances, especially during the promotion for *Don't Worry Darling*. After it transpired that Wilde and Styles began dating on set and parted ways soon after the film was released, the images of the cast together on the red carpet – including a shot of Styles in pieces from his Gucci Ha Ha Ha collection and Wilde in a green suit – were analyzed to the nth degree.

The star also experienced a backlash from the LGBTQI+ community following the release of *My Policeman* and an interview he gave to *Rolling Stone*, where he spoke about how the gay sex depicted was romantic, rather than being "two guys going at it". Writing in the *Guardian*, journalist Guy Lodge took him to task. "Generation Z's greatest pop icon promot[ing] his first overtly queer work on such fusty, coyly old-fashioned terms is a letdown," he wrote.

Having received this mixed reception, it's understandable that Styles might be taking a break from acting for now. But the Harries still have something to look forward to at the cinema. In August 2022, Marvel producer Kevin Feige confirmed that Styles will return to the Marvel Cinematic Universe – potentially in a sequel to *Eternals*. In that outfit and in that world, the role seems like it would require all of Styles's fashion imagination – and that might just mean it's one he was born to play.

"On the most basic level, it's like *being a kid* and you're *playing pretend*."

HARRY STYLES ON ACTING

Go off

When you're a bestselling artist, business mogul and style icon, what you wear off duty can't just be any old thing. It has to be A Thing. Harry Styles knows this well. The outfits he wears on his rare days off might be a bit less razzle-dazzle than his stage looks, but they still exude the kind of flair that most of us can only admire.

Styles is well versed in the power of the band T-shirt to communicate without speaking. He wore designs with the logos of the Rolling Stones, Pink Floyd and Kiss back in his 1D days – as well as more obscure finds, such as a tee from a 1987 tour by country artists Conway Twitty and Loretta Lynn, worn in 2013. He's continued on this theme, sporting a very covetable design for the Beastie Boys's 1994 album *Ill Communication*. Other text has come into the fold too – see a vintage sports jacket with back print reading 'Playdium Skate Club', worn while out and about with Olivia Wilde in 2022.

OPPOSITE A band T-shirt, skinny jeans and shades = a classic rock and roll look from Styles circa 2013.

OVERLEAF A back view is sometimes the best view in fashion. See Styles out and about with then-girlfriend Olivia Wilde, wearing a vintage jacket.

A celebrity of Styles's stature is often photographed at airports (the mind boggles just thinking about his schedule). He's nailed airport style by sticking to the classics. Plain pieces like white T-shirts and wide trousers win, because they look chic but offer an easy comfort too. Like any young person, Styles makes sweats a key part of his day-off uniform. He's been photographed in tracksuits (including an especially smart Gucci one in 2022) and has said that he wore "sweatpants, constantly" during lockdown. He's also long been a fan of the hoodie – whether that's a Jack Wills number circa 2010, a Gucci one in 2017 or a low-key Citizens of Humanity offering in 2022. This reliance on sportswear gives him an endearing quality. Interviewing him for *Rolling Stone* in 2021, journalist Brittany Spanos describes him as "more like your best friend's cute, sporty older brother than the gender-bending style icon he's become" thanks to his outfit of Adidas zip-up jacket, gym shorts and claw clip.

"He's nailed airport style by sticking to the classics. Plain pieces like white T-shirts and wide trousers win."

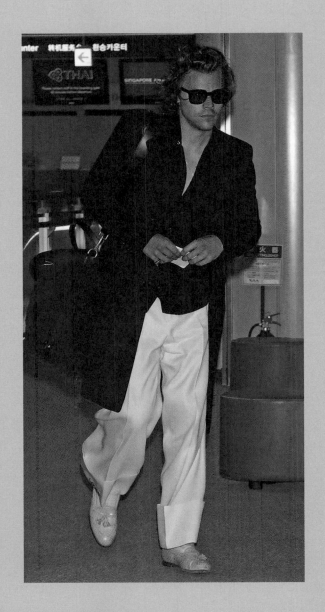

He's nailed airport style by sticking to the classics. Plain
pieces like white T-shirts and wide trousers win.

Sometimes – as the popularity of his JW Anderson cardigan proved in 2020 –what Styles wears when he's even slightly out of the limelight can cause a tidal wave online. A more recent example is an outing in summer 2022. Styles's brother teaches golf and Styles has taken it up as a pastime and, potentially, a wardrobe inspiration. On a golf course in Toronto, he was spotted by a fan's dad in an outfit that couldn't be described as incognito. He'd gone for yellow flares and a green polo shirt, as if channeling 1970s leisure style. The picture was shared nearly 600,000 times on Twitter and received an adoring response from fans. "I love Harry's golf style. It's like he dove through a seventies country club's lost and found and it's glorious," wrote one. If anyone can make golf cool, it's Styles – in fact, you might say this retro off-duty outfit is yet another fashion hole in one. 13 years on from that *X Factor* debut, it's what we have come to expect – and appreciate – from Harry and his style.

Styles wearing Citizens of Humanity hoodie – and matching shorts – when spotted on the street in 2022.

"When you're a bestselling artist, business mogul and style icon, what you wear off duty can't just be any old thing."

Keep smiling – Styles shows off that effortless airport style, and some signature pink trousers, when arriving in Japan in 2017.

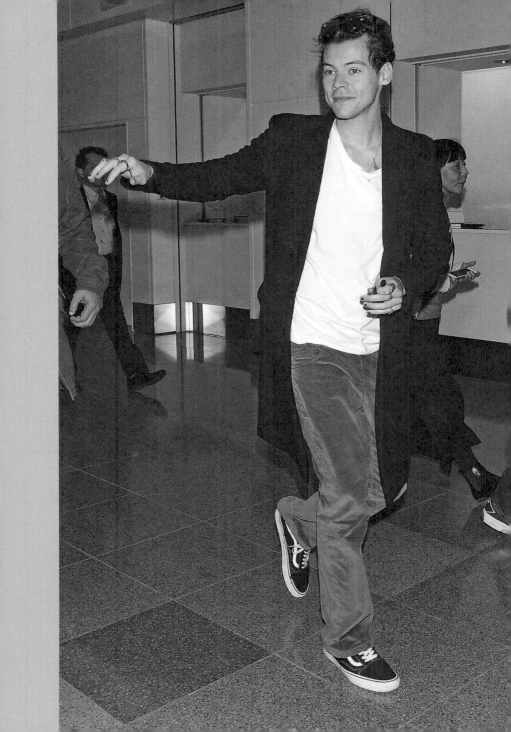

Index

Credits

The publishers would like to thank the following sources for their kind permission to reproduce the pictures in this book:

Alamy: Gonzales Photo 10-11; WENN Rights Ltd 30, 57; Imageplotter 82; Scott Garfitt 96–97; Retro AdArchives 131, 132-133, 134-135, 144; dpa picture alliance 142; Independent Photo Agency Srl 152; Imagespace 155; Barry King 156-157; The Canadian Press 180; Mr Pics 196-197, 200-201; Everett Collection Inc 206-207

Getty Images: Neil Mockford 19; Neil Mockford/FilmMagic 23; Shirlaine Forrest/WireImage 24; Jon Furniss/Wireimage 26; Debra L Rothenberg/FilmMagic 29; David Krieger/Bauer-Griffin/GC Images 31; Mark Robert Milan/Stringer 35; Kim Raff 36; Jon Phillips 37-38; Mike Marsland/WireImage 41; Pascal Le Segretain 42; David M. Benett 45; Rune Hellestad – Corbis 46; Dave J Hogan 47; David M. Benett 48; Kevin Mazur 51; Victor Chavez/WireImage 52-53; SMXRF/Star Max 56; Christie Goodwin/Redferns 58-59; Kevin Mazur 61; Marc Piasecki/GC Images 62; Dia Dipasupil/FilmMagic 67; Robert Kamau/GC Images 68; John Shearer 71; Gijsbert Hanekroot/Redferns 72; Kevin Mazur 77; Kevin Winter 79; JMEnternational 86; Steve Jennings 89; JC Olivera/WireImage 92-93; Joseph Okpako/WireImage 95; Kevin Mazur 99; Dia Dipasupil 101; John Lamparski/WireImage 103; Anthony Pham 104; Kevin Mazur 110-111; Gareth Cattermole/BFC 115; Jason Merritt 116; Karwai Tang/WireImage 118-119; David M. Benett 123; Kevin Mazur 124; Kevin Mazur 126; Jeff Kravitz 136; Kevin Mazur 139; Terence Patrick/CBS 141; Jo Hale 145; FREDERIC J. BROWN/ AFP 148-149; TIZIANA FABI/AFP 151; JNI/Star Max 159; Streetstyleshooters 160; Peter White 163; Mark Robert Milan/FilmMagic 166; J. Lee/FilmMagic 169; Tim Whitby 170; Jeff Kravitz/FilmMagic for Sony Music 172-173; Kevin Mazur/Getty Images for Sony Music 175; JC Olivera/Stringer 176; Kevin Mazur 178-179; Axelle/Bauer-Griffin/FilmMagic 181; Kevin Mazur 183; Kevin Mazur 187; Alexi Rosenfeld 190-191; Neil Mockford 205; Olivia Salazar/WireImage 210; Neil Mockford 212-213; Gotham 216; Jun Sato 219

Shutterstock: Beretta/Sims 15, 20, 33, 168, 202; F Carter Smith/AP 74; Roger Bamber 76; Anthony Harvey 85; Roma/IPA 88; Evan Agostini/Invision/AP 128-129; Richard Young 146, 147; Masatoshi Okauchi 215

Watti Cheung: 81
Amy McKeon: 107
Cathryn Kuczynski/PhotosByCatMedia: 108, 192

Every effort has been made to acknowledge correctly and contact the source and/or copyright holder of each picture and Welbeck Publishing apologises for an unintentional errors or omissions, which will be corrected in future editions of this book.